THE COMPLETE GUIDE TO

LIGHT

THE COMPLETE GUIDE TO
LIGHT

MARK CLEGHORN

photographers'
pip
institute press

First published 2008 by
Photographers' Institute Press
an imprint of The Guild of Master Craftsman
Publications Ltd,
166 High Street, Lewes, East Sussex BN7 1XU

Reprinted 2010

ISBN 978-1-86108-526-9

British Cataloguing in Publication Data.
A catalogue record of this book is available
from the British Library.

Associate Publisher: Jonathan Bailey
Production Manager: Jim Bulley
Managing Editor: Gerrie Purcell
Project Editor: Ailsa McWhinnie
Managing Art Editor: Gilda Pacitti
Designer: Ali Walper

Colour reproduction by GMC Reprographics
Printed and bound by Hing Yip Printing Co. Ltd. China

CONTENTS

INTRODUCTION

Lighting isn't a black art. In fact, when you break it down, using and manipulating light is quite simple. Even though the way we capture images has changed over the years, whether you shoot digitally or with film, the one secret ingredient to all great images is the way in which they have been lit.

The photographer's ability to understand light is taken for granted by those who commission images – whether it's for a magazine layout or to record someone's special day. However, many professional photographers admit they don't fully understand lighting patterns and shadow-to-highlight ratios. In fact, many simply rely on 'suck-it-and-see' or, even worse, checking the image on the camera's LCD screen and making adjustments based on that.

This book is designed to help you make the most of light for all eventualities, and deals with both natural light and flash, explaining how it is manipulated to give a three-dimensional form to the subject. I make no apologies for covering a certain amount of basic information, as this is often the area where photographers fall down. Like a chef adding too much or too little seasoning to a dish, a potentially successful photograph can end up looking ordinary due to a poor understanding of light. Making fine adjustments to the camera angle, thus altering

the way in which the light falls onto the subject, exploiting natural light to its best advantage, and the understanding of the technicalities of using on- and off-camera flash are just some of the areas that are tackled in this book.

If it sounds daunting, don't worry. There are only a few general principles in the use of light and, once you master these key techniques, the lighting of any subject is possible. The secret is to keep it simple, making each lighting element – especially with flash photography – do one job and one job only, while adding further sources only to create form and depth.

By applying the techniques in this book to your images, your portfolio will be transformed. Even more importantly, you will raise your awareness of light and its effect on a subject, putting you in the position where you are in control, and understand how to manipulate it for dramatic effect. The end result will be that, rather than worrying about technique, your photography will be more fun – which is exactly what it should be.

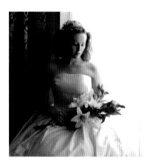

UNDERSTANDING LIGHT

UNDERSTANDING LIGHT

Seeing the light is the secret to all photography. Whether your chosen subject is still life, landscape or portrait, the right light falling onto a subject gives shape and depth, helping to create a three-dimensional effect within the final print. As a result, the viewer is afforded a sense of scale as well as texture and solidity.

Lighting is always at its most effective when it is kept simple. Just as we observe life with the sun providing illumination from one direction, so we should rely on one light and one direction in our photography. Having said that, images can be dramatic when you master a few key rules of manipulation. By featuring additional lighting the subject can be enhanced further, but the most important thing is to keep the image looking realistic.

Remember, the camera does not record the tiny variations in light that the human eye is aware of. The camera needs to be told what to see and what to expose for, just like our brain tells our eyes which part of a scene we wish to see detail in, by compensating for any unwanted brightness or darkness we may wish to ignore.

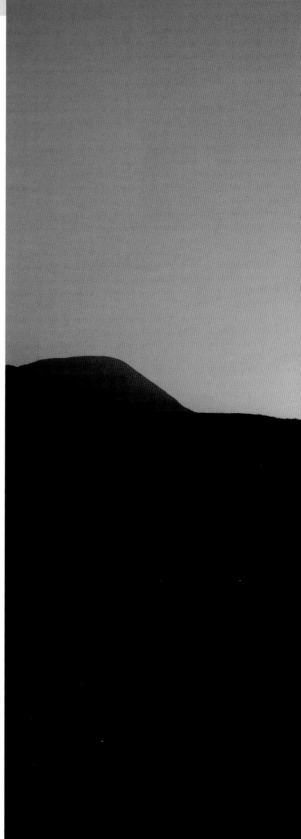

➤ *A successful photograph – whether landscape, portrait or still life – requires an understanding of the quality of light.*

▼ *The warmth of light at either end of the day cannot be beaten for atmosphere and softness.*

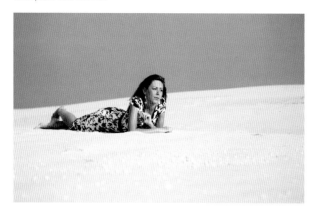

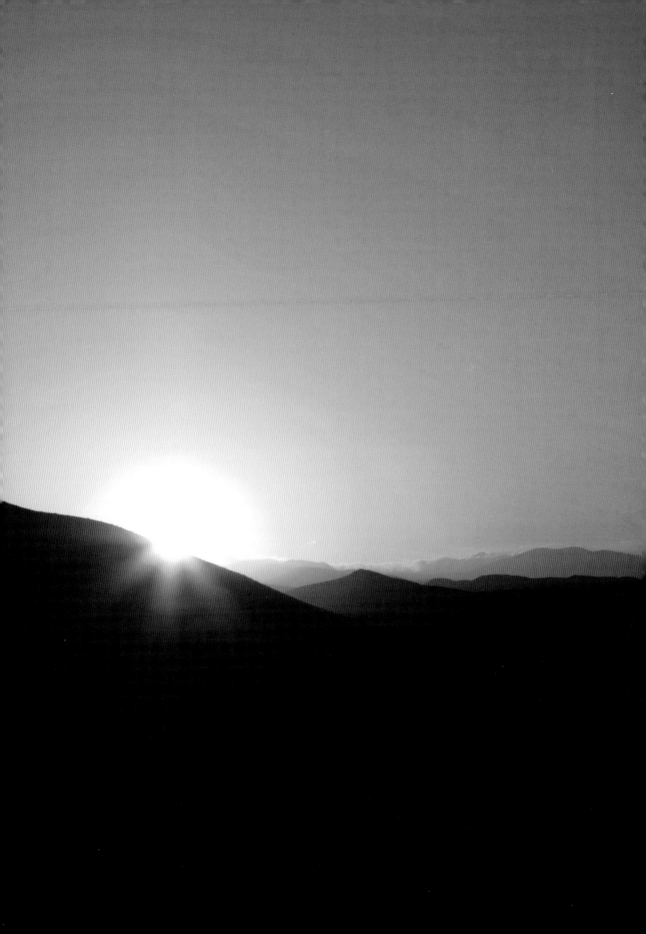

EXPOSURE

While nearly all cameras allow you to set the exposure automatically, as your photographic skills improve you should consider using the manual controls. This puts you in charge of recording the finer detail, instead of asking the camera to guess what it is you're exposing for.

In order to obtain a correct exposure, a number of factors must be taken into consideration. Do you require more or less depth of field to obtain the level of sharpness you envisage? Do you plan to use a fast shutter speed to freeze movement, or a long one to create motion blur? How much flash – if any – is required to complete the image?

When an image is overexposed, highlight detail is lost, and contrast increased. Underexposed images appear muddy with little contrast. Correct exposure is based on an 18 per cent grey, which allows all tones either side of it to be recorded. The result is a smooth transition in colours as well as a blending from highlight to shadow.

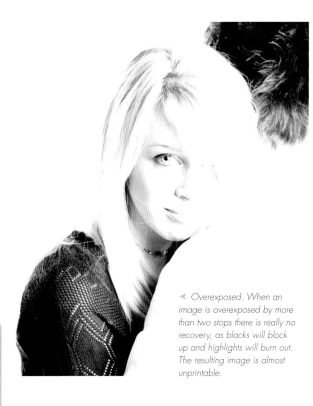

◄ Overexposed. When an image is overexposed by more than two stops there is really no recovery, as blacks will block up and highlights will burn out. The resulting image is almost unprintable.

spotlight

If the image looks too dark the shutter speed should be reduced or the aperture opened up. If the image is too bright the shutter speed should be increased or the aperture closed down.

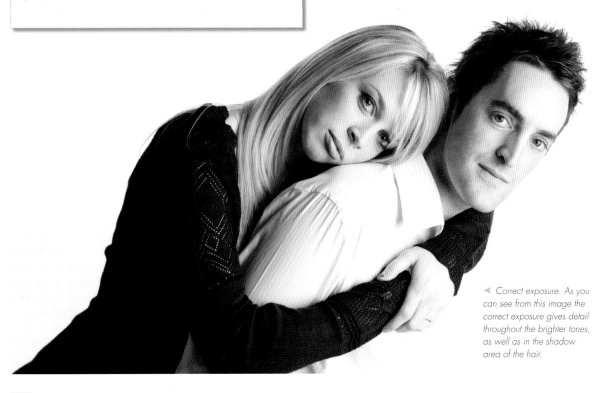

◄ Correct exposure. As you can see from this image the correct exposure gives detail throughout the brighter tones, as well as in the shadow area of the hair.

METERING FOR EXPOSURE

HOW TO TAKE A HANDHELD INCIDENT METER READING

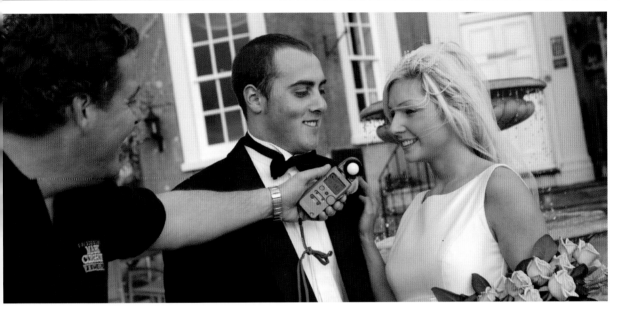

▲ For a portrait: Point the meter towards the main light source. This will take a reading for the 18 per cent value, and give detail in the whites. If you point it slightly away from the main source you will slightly overexpose the image and lose detail in the higher values.

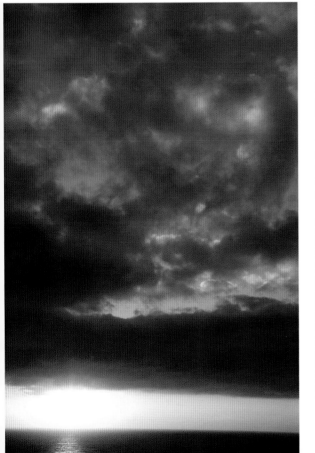

spotlight

When taking a spotmeter reading, ask yourself whether the subject you are metering for is lighter or darker than a mid-tone grey and adjust your exposure accordingly.

◄ For a landscape: If the sun is high in the sky or behind you, meter directly from it, as it will be evenly lighting the whole location. For evening scenes where you wish to record the detail in the sky, again, point the meter towards the setting sun, making sure it isn't obstructed by anything. It is more accurate to use a reflected reading for landscapes.

spotlight

Handheld and in-camera meters are calibrated to expose for the average mid tone, which is 18 per cent of the reflected light of the subject, and referred to as an 18 per cent grey. In principle, the meter is trying to set an average exposure over the whole scene to allow for a mid-tone image, so the image can have a solid black and a white with detail.

TTL METERING

APERTURE AND SHUTTER PRIORITY

Aperture priority allows you to set the aperture, while the camera chooses the shutter speed accordingly. This setting is useful when shooting weddings if you prefer to use a wider aperture – say, f/4 to 5.6 – and thus have a faster shutter speed. The shutter priority setting allows you to choose the shutter speed, while the camera selects an appropriate aperture. This is useful when shooting in low light.

MULTI-PATTERN

This is the most advanced of the metering options, as it takes multiple readings across the image and combines them for one reading. It's an ideal setting when you have to just point and shoot as the multiple readings will allow more for large areas of dark and light, but the metering can still be fooled by high contrast settings.

CENTREWEIGHTED

This setting takes multiple metering readings across the image but gives emphasis to the centre of the frame, which makes it useful for close group shots. The results are more predictable than with multi-pattern, but you should still take care with large areas of light or dark, which can fool the meter. Centreweighted metering is a useful option when using, for example, polarizing filters.

SPOT

This mode can be ideal for portraiture – as long as you fill the spot with the main subject – as it exposes just for that small area and ignores any surrounding areas that might be very bright or dark. More advanced cameras feature a variety of different spots within the viewfinder, which allows you to set both exposure and composition at the same time.

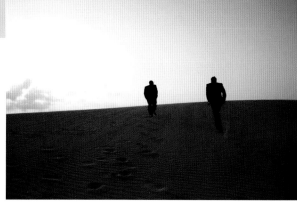

▲ By using manual exposure, I was able to take a reading from an 18 per cent grey area, and set my aperture and shutter speed accordingly. The result shows detail in the sand, subjects and sky.

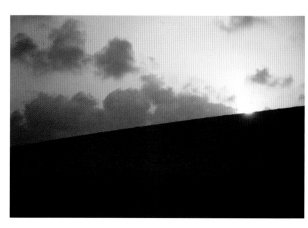

▲ Compare this with a picture taken on the automatic setting, which shows how the meter was fooled by the large area of sky, so underexposed the sand.

▼ One problem that can arise when using your camera on automatic is a slight change in exposure as your position changes or you zoom in with your lens. This can be very frustrating, and means extra work at the postproduction stage.

LIGHTMETERS AND MANUAL METERING

Once you've gained some experience, you'll find that using the manual setting on your camera is much more consistent, and you'll work more quickly and accurately.

To take an exposure reading manually I simply position my meter close to the subject's face and point it towards the light source. The meter records an 18 per cent value of the highlight; this reading is then simply set on the camera's shutter speed and aperture to give the correct exposure. Remember to make sure the ISO value is the same on both camera and meter.

▲ A multi-pattern exposure is best for this type of image as the exposure is weighted for the centre of the image.

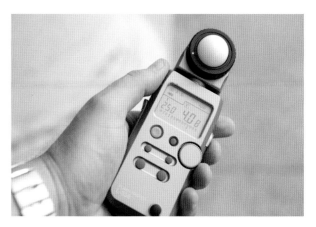

▲ Many lightmeters, such as this Sekonic Flashmaster L-358, can expose for ambient light as well as flash. It also features multiple ISO settings, allowing the user to switch between bright sunlight and dark interiors quickly. Some meters come with accessories, enabling the photographer to take both incident and reflective readings.

◄ TOP The area covered in evaluative metering mode.

MIDDLE The area covered in centreweighted metering mode.

BOTTOM The area covered in spotmetering mode.

▲ A spotmeter reading is ideal for bright scenes. Without it, this photograph would have been underexposed.

FLAT LIGHTING

The direction from which light hits a subject greatly affects a photograph. If the main light source is directly above or in front of the subject, the result will be flat. This is not usually desirable, as the result will lack shadows and, therefore, depth. Overcast weather also gives a similar result.

SIDE LIGHTING

In most cases, side lighting is considered the ideal direction for light to fall on a subject. Side lighting creates shadows as it crosses the subject, thus producing contrast and texture – qualities considered pleasing in a photograph.

BACKLIGHTING

When light comes from behind the subject it is referred to as backlighting, or rim lighting. This can result in very powerful landscapes, especially those that feature water. Backlighting can create powerful silhouettes from strong, graphic shapes against a background or sky. In portraiture, however, photographers often use a reflector or flash to fill some of the foreground shadow area.

TOP LIGHTING

Top lighting is pretty self-explanatory but, like flat lighting, is generally considered to be detrimental to a photograph. In sunny conditions top lighting does create contrast and shadows, but these shadows will fall in a subject's eye sockets and under the nose, which is very unattractive. As a result, this direction is considered to be something of a no-no in portraiture.

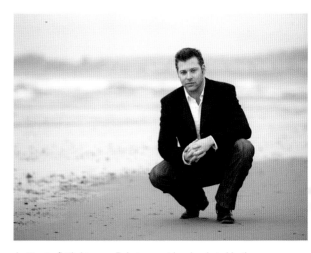

▲ Despite flat light generally being considered undesirable, there are occasions when it can give pleasing results.

spotlight

Whatever direction the light is coming from, it can be manipulated to the photographer's advantage. In still life and portraiture, for example, a reflector can be used to bounce light back onto the subject, or to cut down on light if positioned between the light source and subject.

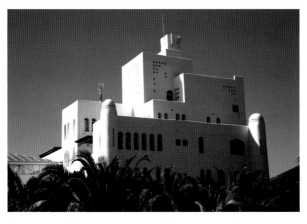

▲ Architectural photography relies on side lighting to come alive.

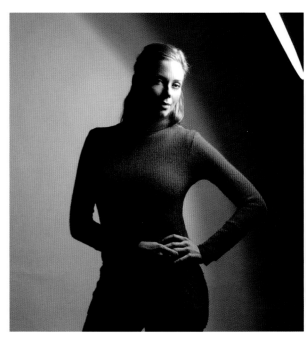

▲ Side lighting gives a subject depth because of the increase in shadow.

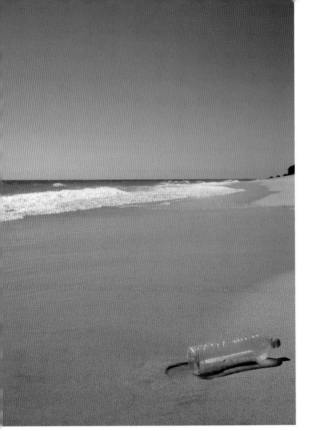

PROFESSIONAL HINT

Find a round object and use a standard room lamp to illuminate it. Start with the lamp positioned to one side, then slowly move it 360 degrees around the object, taking a series of pictures as you go. In this way, the lamps acts as a miniature sun.

Review your images, taking note of the depth and direction of the shadows.

Now, re-position the lamp slightly higher to create a shallower shadow, and follow the same procedure as above. Analyzing the results will help you the next time you are out in the field.

▲ When the light source is directly overhead, very little contrast is evident. However, including water, or anything with a reflective surface, helps bring the image alive.

▲ Backlighting creates graphic shapes in portraiture; any delicate fabrics will have added texture and luminosity.

◄ Backlighting emphazises the texture of any plant subject.

spotlight

To create great images every time, try to have the light falling on a scene or subject at an angle of approximately 45 degrees to the camera. If the direction of light isn't quite right, either move the camera position or wait until a different time of day.

THE QUALITY OF LIGHT

The quality of light should not be confused with the level or direction of light, as each contributes to the overall make-up of an image in a different way. The term quality of light refers to the softness or sharpness of light, and is also known as specularity. Even on a dull, overcast day we can increase the specularity by altering a subject's position and, if necessary, reducing some of the ambient light with a dark reflector. This gives the light more direction, hence more apparent sharpness. When shooting landscapes the same effect can be achieved with filters.

CONTRAST

The distance between light source and subject affects the quality of light. Too close, and the subject will be very bright on one side, and in dark shadow on the other; too distant, and the subject will appear flat.

▲ Contrast

SOFT LIGHTING

Light is considered soft when it is diffused by a cloud (in the case of the sun), or a softbox (in the case of a flash unit). When light is diffused its contrast is reduced, which in turn creates softness. Soft lighting is pleasing for portraits as it tends to be flattering and forgiving towards flaws in the skin. It is also a prerequisite when photographing waterfalls, as the contrast between the highlights on the water and shadows in the rest of the scene are greatly reduced, making exposure more straightforward.

HARD LIGHTING

Hard light is, not surprisingly, the opposite to soft lighting, and is a result of direct sunlight, or a bare flash bulb. The raw light source exaggerates contrast and gives the subject sharply defined edges. On a bright, sunny day, therefore, the quantity of light will be abundant, while the quality will be very sharp. The harsh shadows that result from this make it difficult to retain detail in the shadow areas, although this can be modified with a reflector. On sunny, hard-lit days, placing

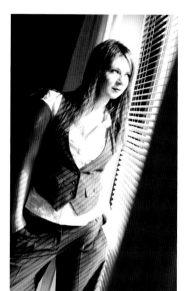

▲ Hard light

the subject with their back to the sun results in rim lighting around the edge, but a softer appearance on the face due to the reduction in glare. However, if the light is flat or muddy, use of a reflector or fill flash increases sharpness, particularly when shooting group portraits.

▲ Soft Light

FEATHER LIGHTING

Just before it becomes muddy or dull, light is feathered. It can be achieved with both flash and ambient light, as long as the light source has an edge, such as a window, doorway or softbox. This edge slightly softens the light, while retaining a certain level of sharpness, and is particularly effective with portraits and still life. Choose your subject's position carefully: too close and the light will be at its sharpest, while too far and the result will be muddy.

▲ *Feathered light*

▲ *This sequence shows how it is possible to manipulate the direction and quality of light with a reflector.*

1 *Shade*

2 *Reflector to subject's left*

3 *Reflector to subject's right*

THE COLOUR OF LIGHT

Our eyes are easily fooled. In digital terms, it could be said they have an automatic white balance. Whether using our eyes at dawn or dusk, inside or outside, our brain compensates and adjusts the information so that we see neutral tones. All we are aware of is a change in brightness. However, to camera film, or a CCD, the change is dramatic, and produces a cast based on the subject's colour temperature.

⋏ *This portrait was taken at dawn. Whether shot at the beginning or end of the day, photographs will have a similar warmth as long as they are composed with the sun hitting the subject or location.*

GUIDE TO COLOUR TEMPERATURE

The effect of colour temperature can be seen by photographing the same subject in different conditions. Take the first picture during normal daylight hours. The camera will record a natural skin tone with a blue hue in the shadows. Then photograph the same person inside a darkened, candle-lit room. The subject and shadows will feature a deep orange cast, because of the colour temperature of the candle.

This change occurs because of the variation in colour temperature, which is measured in degrees Kelvin.

Sunrise/sunset 2500K
Early morning and evening sunlight 3500K
Mid-afternoon sunlight 4500K
Early afternoon 5000K
Average daylight 5500K
Overcast sky 6000K
Shade in daylight 6500K
Partial cloud 7000K
Cloudy sky 7500K
Blue sky 10000K

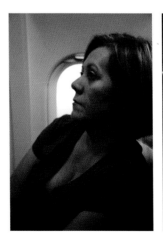

⋏ *The natural light outside isn't strong enough to cancel out the green cast thrown onto my wife, Debbie, from the aeroplane's artificial cabin lighting.*

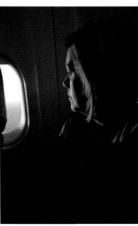

⋏ *Here, the setting sun floods onto Debbie's face, hence the vibrant and evocative orange cast.*

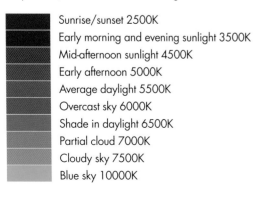

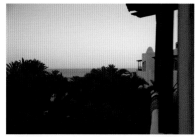

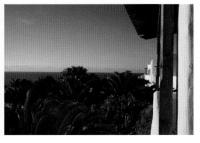

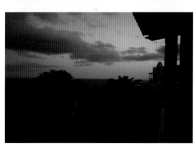

▲ These images show how dramatically the colour of light falling on the same scene changes as the day progresses from sunrise to sunset and then back to dawn. At sunrise the light is warm, balancing out to white towards the middle of the day, until a blue hue is introduced into the shadows as the sun sets.

Film	Kelvin	Illumination	Kelvin	Filter	Colour	Exposure compensation
Daylight	5500K	Tungsten house lights	3200K	80A	Dark blue	+1 ⅓
Daylight	5500K	Tungsten photofloods	3400K	80B	Dark blue	+1
Daylight	5500K	Tungsten clear flash bulbs	3800K	80C	Dark blue	+1
Daylight	5500K	Daylight shade under blue sky	7500K	81EF	Straw	+ ⅔
Daylight	5500K	Daylight shade partly cloudy sky	7000K	81D	Straw	+ ⅓
Daylight	5500K	Daylight shade under daylight	6500K	81C	Straw	+ ⅓
Daylight	5500K	Daylight overcast	6000K	81A	Straw	+ ⅓
Tungsten A	3400K	Daylight	5500K	85	Orange	+1
Tungsten B	3200K	Daylight	5500K	85B	Orange	+1
Tungsten	3800K	Daylight	5500K	85C	Orange	+1
Tungsten B	3200K	Tungsten lights 100W	2900K	82B	Pale blue	+ ⅓
Tungsten B	3200K	Tungsten photofloods	3400K	81A	Straw	+ ⅓
Tungsten A	3400K	Tungsten lights 100W	2900K	82C	Pale blue	+ ⅓
Tungsten A	3400K	Tungsten clear flash bulbs	3800K	81C	Straw	+ ⅓

▲ This table demonstrates how – depending on the combination of film lighting conditions – casts can be balanced out according to the colour correction filter used.

spotlight

Flash is balanced for daylight, so has a slightly blue cast. This can be seen when shooting interiors with a combination of flash, tungsten lighting and slow shutter speeds. The lighting will have a warm colour cast if it is tungsten, and a green cast if it is fluorescent.

COLOUR TEMPERATURE AND WHITE BALANCE

As with all areas of photography, lighting and tone are subjective. However, it's important to understand how light works and how to alter any colour casts – both in-camera and, if necessary, in postproduction. Film photographers use a colour temperature meter to match any filtering to the ambient colour, while digital photographers use appropriate postproduction software.

Colour correction filters are essential when shooting film. The 80 and 85 series are strong blue and strong amber respectively, with the 80 used to correct daylight film under tungsten lighting conditions, and the 85 to correct tungsten film used in daylight. The 81 and 82 series are more subtle.

With digital photography, however, the camera can simply be set to auto white balance. Many DSLR cameras can be set to different colour balance modes in order to match the lighting conditions and allow the photographer to control colour casts accurately. When shooting RAW, colour can be adjusted in postproduction with little effort.

COLOUR BALANCING

A number of simple accessories are available to help with white balancing in-camera. My preference is for the ExpoDisc. Straightforward to use, it is first positioned in front of the lens. A reading is then taken of the ambient light, which passes through the diffuse filter; a balance is then taken and set on-camera as a custom setting.

Some photographs can be difficult to colour correct fully, especially interiors that feature a mixture of tungsten and natural light. In cases such as these, a 'crossover' in colour occurs. Large sheets of coloured gels can be used on the windows to balance out the natural light, but this is very time consuming. In today's digital world, blending images together in Photoshop is a more cost-effective way of obtaining fully professional results.

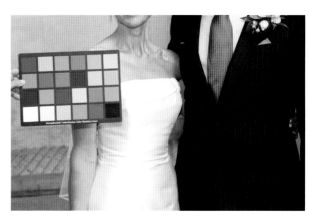

▲ The Gretag Macbeth Colour Checker is an expensive but extremely useful colour guide. Not only can white and black points can be mapped for shadows and highlights, but also the grey point for accurate colour rendition.

▲ Lastolite makes a compact grey balance reflector, designed for heavy usage, and which should fit into almost any camera bag. The reflector is designed for use either when custom setting the camera while on location, or by click balancing in postproduction.

WHITE BALANCE

Setting the camera's white balance may seem like a no-brainer, but choosing the right balance for the environment helps avoid too much correcting at the postproduction stage. Setting the camera to auto balance is rarely the ideal solution as the camera tries to calculate the best white point in the photograph. Remember, when the camera is on auto, it always looks for a neutral grey. Therefore, if an image is, for example, a landscape featuring a lot of green grass and trees in leaf, the camera will produce a slightly warm image (magenta) as this is green's opposite colour. Conversely, if an image is dominated by, say, a red door, the camera will produce a blue tone (cyan); again, its opposite colour.

I prefer to set my camera to flash balance as this gives me a uniform colour – similar to film – at all times, without deviating according to the surroundings or other elements in the photograph. These images can then be corrected en masse, quickly and accurately, in postproduction. Many film photographers will rely on their processing labs to correct any colour casts. Colour correction is simple as long as you follow a few basic rules.

CAMERA COLOUR

Setting the camera's white balance changes a photograph's overall tone, as it alters the image's white point, hence changes the tonal values from warm to cold. The images (above right) were shot consecutively on the camera's various colour settings, based on the Canon EOS 5D colour pre-sets.

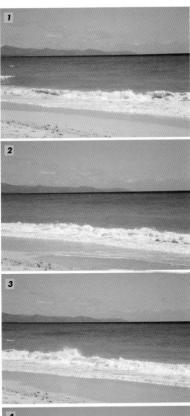

1 Auto white balance may seem an easy option but it can be fooled, especially when the image is dominated by one colour. The camera measured the scene at 5500K.

2 Daylight mode sets the white point for the middle of a sunny day. The camera measured the scene at 4950K.

3 Shade mode increases the warmth of the image to compensate for an expected blue hue. The camera measured the scene at 6300K.

4 Cloudy mode increases the warmth even more to compensate for more shade. The camera measured the scene at 4750K.

5 Tungsten mode increases the level of blue in the image to compensate for the expected yellow/orange cast. The camera measured the scene at 3200K.

6 Fluorescent white mode increases both blue and, less so, magenta, to compensate. The camera measured the scene at 3950K.

7 Flash mode sets the colour balance warmer to allow for the slight blue cast emitted by a flash. The camera measured the scene at 5900K.

8 The custom balance can be the most effective, but takes a little longer to set an exact colour based on a manual setting applied to the camera. The camera measured the scene at 5300K.

spotlight

If shooting a Gretag Macbeth Colour Chart the contrast can also be set at the same time by selecting the black point and white point in the levels.

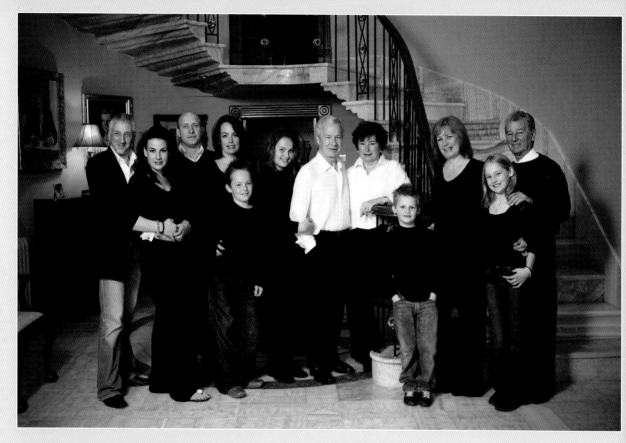

To achieve a great image every time it is important to match the lighting to your subject, otherwise the images lose their dynamism and overall impact.

PORTRAITS

The decision whether to use hard or soft lighting on a location shoot is taken out of our hands, as the elements control what the photographer has to work with. However, when working in the studio or with flash as the main light source, more thought needs to be given to matching the quality of light with the subject and surroundings.

Hard lighting might result in a more dynamic portrait, but care needs to be taken, as it also exaggerates any facial flaws and increases the potential for error on the part of the photographer, as placement of the light becomes even more crucial. Soft lighting, conversely, gives more pleasing results, although loss of contrast can result in flat portraits if the lighting is not exploited to its optimum potential.

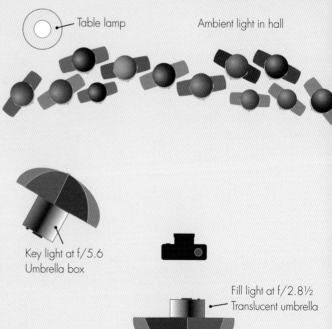

Table lamp

Ambient light in hall

Key light at f/5.6
Umbrella box

Fill light at f/2.8½
Translucent umbrella

▲ A softbox is a simple diffuser of light and is ideal for close-up photography when a subtle transition from shadow to highlight is needed. The soft light gives the skin an attractive overall tone and does not exaggerate facial flaws.

◄ When shooting in a client's home, using the interior as a background, it is important to enhance the ambient lighting with supplementary flash, otherwise it will look dark and lifeless. The first thing I did with this portrait was to switch on all the room lighting, including any small lamps. I used this reading as my fill light, adjusting my ISO to match my desired working shutter speed and aperture. A single studio flash fitted with an umbrella box was then set up at 45 degrees and set to 1½ stops more than the ambient reading. This compensated reading was then set on the camera's aperture. The umbrella box works similarly to a softbox, by diffusing the light source to give a soft illumination. The warmth of the ambient lighting sets the mood, while the flash gives me my working aperture and clean white light for skin tone.

▲ To increase the drama in this portrait I used a spotlight attachment on the flash to create a directional hard light source. The spotlight creates hard shadows, while a fill light was used behind the camera to give some information in the darker areas.

spotlight

If the subject is wearing funky clothes try using a harder light source, as this will increase the drama and impact.

SOFT LIGHTING

The majority of portrait photographers prefer soft lighting for portraits, as the light from a softbox or an umbrella is diffused before it falls onto the subject. However, directional light of some sort is preferable if we are to record at least a little subtle shadow detail.

HARD LIGHTING

For editorial-style portraits or images intended to be punchy, a harder light source is needed to increase contrast. The bare bulb technique is popular for hard lighting, as the flash is not diffused before it falls on the subject. Flash adapters – called reflector dishes – can be used to control the shape of the light for even greater effect.

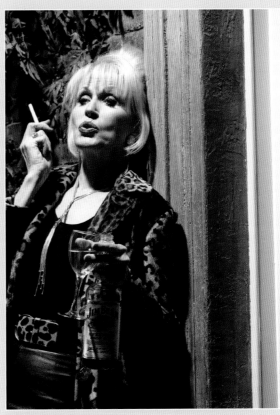

▲ For this editorial portrait of a Joanna Lumley look-alike, I used a hard light source set above and slightly behind the model to give the impression of street lighting. Even though this portrait was shot in a studio set and not on location, the lighting effect is the same. The bare bulb technique was used, with the flash direction controlled by a reflector dish; the harsh effect of the light and its direction can be seen on the face with the increased shadow creating bags under the eyes.

Matching a location to its light source is more difficult as the natural elements play such a huge part. However, the time of day dramatically changes your landscapes, and there is always the option of manipulating the result with digital postproduction. Having said that, it's always better to obtain as close a result as possible on the day, even if it means using filters to change the hue and tone of the image.

LANDSCAPES

The light that falls on a landscape always varies, as each day brings a slightly different mood. Hard light from the sun, or soft lighting when diffused by cloud cover, all contribute to successful results – but matching the scene with the quality of light can result in a timeless image. The time of day is the most important consideration, as the direction of the sun can enhance – but, if used poorly, detract from – the main focal point of the composition.

▼ *Contrast plays a huge part in landscape photography. When photographing in the midday sun, where it is directly overhead, any shadows fall straight down and produce little contrast. To overcome this problem I try to use buildings to create contrast in the scene as well as colour, for greater impact.*

▲ *After a snowfall I prefer to make the most of the softer light from a cloudy sky to create images with little contrast. The nature of the reflected light means that shadows are filled, naturally making the image grey and white instead of black and white – even when shooting colour.*

◄ *Simple images can be deceptive. This composition of sand and sky is successful on several counts: strong side lighting, only two dominant colours – the blue sky and yellow sand – and, of course, the pattern in the sand juxtaposed with the plain sky.*

PRODUCT PHOTOGRAPHY AND STILL LIFE

Shooting a product or still life is very much like a portrait, as you can manipulate the effect either with natural light or flash, depending on the subject and scene. Soft light will give very gentle images with muted colours and shadows, whereas strong sunlight results in bold colours with harsher shadows and more contrast.

spotlight

For a balanced composition, look for similar tones, so neither highlight or shadow dominates the scene.

▲ When an object is simple by design, and features an interesting shape but no detail, a silhouette with the right sky results in a very effective still life. Here, I used spotmetering, measuring from the setting sun, which creates saturated colours in the sky and didn't allow any detail to record in the sandcastle itself.

spotlight

When shooting with tungsten, experiment with the different colour settings on your digital camera for a variety of effects.

▲ This still life of a sculpture made of metal screws wrapped in material was taken for the artist's portfolio before the sculpture was sold. The piece reminded me of something from a sci-fi film, so I set up just one soft light from the side, but used only a tungsten bulb instead of flash. The reason for this was twofold: the first and main reason was to shoot with a wide open aperture to give a shallow depth of field; the second was to use the yellow glow from the ambient light to add some mood. If desired, this colour cast could have been removed later in Photoshop.

◄ When shooting food I try to keep the lighting as simple as possible. This picture was taken on location, using the kitchen's hotplate lighting to illuminate the food. I used a piece of silver foil to reflect a little light back onto the strawberries and give them some more sparkle.

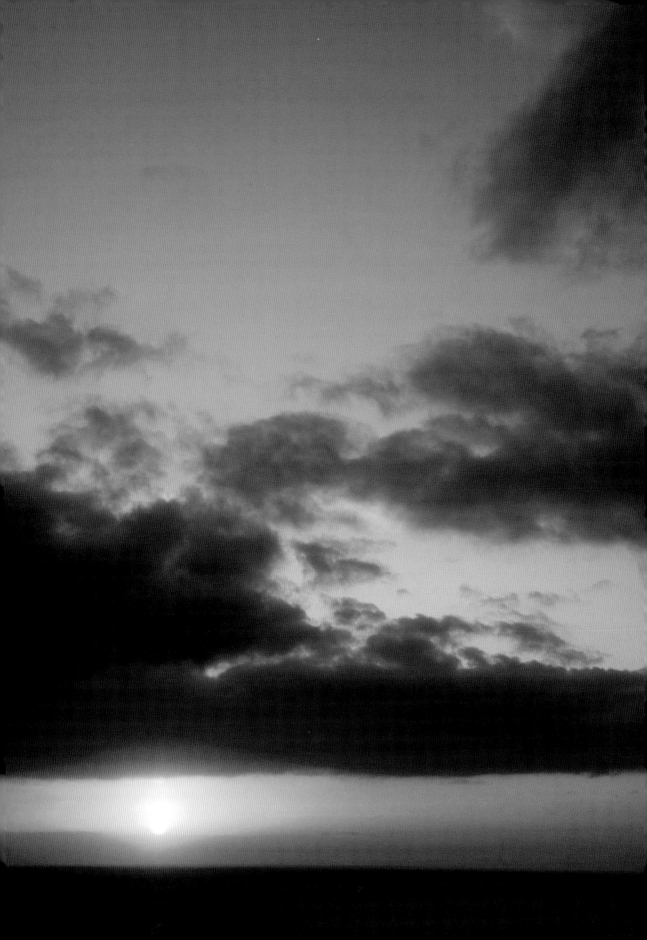

AMBIENT LIGHT

AMBIENT LIGHT

Lighting is always at its most effective when it is kept simple. Everything we observe during daylight is lit from one direction. As a result, it makes sense to have one light and use it only in one direction in our photography. Having said that, images can be dramatic when you master a few key rules of manipulation, but the most important thing is to keep the image looking realistic.

Remember, the camera does not record the tiny variations in light that the human eye is aware of. The camera needs to be told what to see and what to expose for, just like our brain tells our eyes which part of a scene we wish to see detail in, by 'filtering out' any unwanted brightness or darkness.

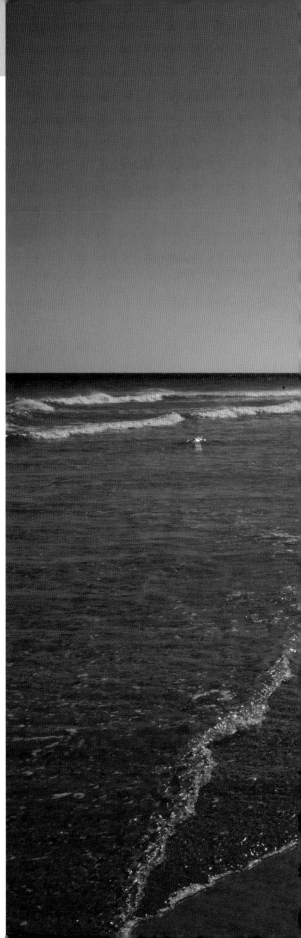

➤ *Although we cannot control natural light, we can modify it in order to achieve a successful photograph.*

▼ *By choosing appropriate lighting, we can create a mood of either drama or subtlety.*

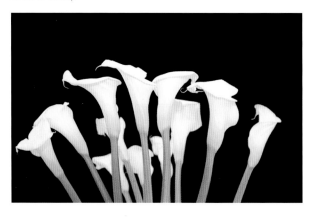

AMBIENT LIGHT: INSIDE AND OUT

Ambient light refers to the natural light in a room or scene – whether artificial or sunlight. Most photographers start out using ambient light, before graduating to flash for more complex, sophisticated results.

Ambient light can be used as the main source of illumination in a photograph if the quality and the level is appropriate. However, generally speaking, it is more suitable as a fill – especially in portraiture, where an extra light source like a window or an off-camera flash is used to give direction and contrast to the subject.

DAYLIGHT

Whether inside or out, using natural daylight is a good starting point for any photographer. Consider the sun as one enormous softbox whose direction, depending on the time of day, can be used for a variety of creative effects. In its rawest form, ambient light has no diffusion, is clean in colour and specularity, but rather harsh.

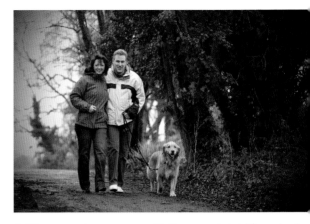

▲ *When a scene has an even overall light, exposure is straightforward and the results will be usable, if slightly flat.*

▼ *To make the most of the direction of the ambient light, I posed the subjects by turning them towards the open sky behind them. On such an overcast day the trees above act as a subtraction of some of the ambience, allowing the light behind to give specularity.*

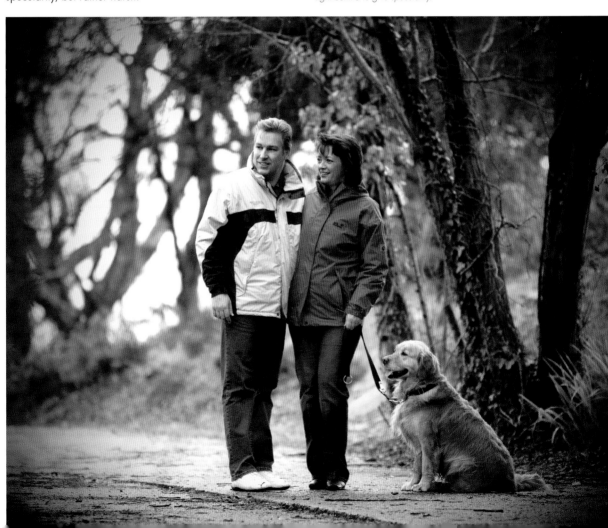

▼ When a scene is illuminated only by artificial lighting, then technically this becomes the ambient light.

ARTIFICIAL LIGHT

If the ambient light is artificial – say from a lamp in a room, or from a car's headlights – the characteristics are similar to that of ambient daylight. The one exception to this, of course, is when a lamp producing the main source of light has a cover on it. This, of course, diffuses the harshness of the bulb, in the same way as harsh sunlight might be diffused through a tree canopy, or by bouncing off a wall before hitting the subject.

◄ When there is a visible light source, like a window, there will always be a direction to the ambient light, helping to give texture and form to the subject.

◄ When an interior is lit mainly by tungsten, the overall ambient light level will be warm in tone. Low-voltage ceiling lights give out a more specular light, which helps give direction to the ambient light and also creates more contrast.

spotlight

When shooting in a room lit by lamps or overhead lighting, try exposing at 1/15sec at f/5.6, at ISO 100, as a starting point to record the overall ambience of the scene.

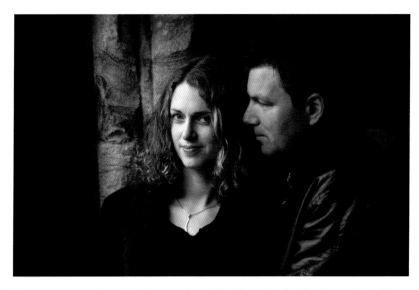

▲ *On overcast winter days, when shooting with available light outside, I look for a location that will bring some direction to the light and therefore contrast to the image. Pillars are ideal for this.*

You are at the mercy of the elements when working on location, but the trick is to find places where you will achieve successful results under a variety of lighting conditions and at different times of year. That way you increase your chances of success – even on wet or dull days – without having to wait for another window of opportunity.

Location is fundamental when shooting outdoors. In the same way that a window is crucial to using natural light inside, a 'window of light' is just as important when shooting outside. This might be a gap in the tree canopy, a space between pillars, or even a doorway. All give direction to the light.

THE FIRST TREE IN THE WOOD

The saying among photographers, 'The first tree in the wood', forms the basis of all outdoor photography. It refers to the fact that the first tree in a wood is the one that's closest to the clean, white light, and therefore unaffected by green casts. The 'second tree' would be affected in a way that the first isn't. The first tree in the wood also gets more light than the second or third, because it is closer to the light source, therefore sharper. Any trees that are further in appear flatter and muddier, as the light levels reduce, along with the quality.

Background

Daylight

Reflector

spotlight

When using a reflector to fill in any dark shadow areas created by strong directional light, make sure you use the reflector on the same side as the light source, and angle it back to the light for a more realistic result.

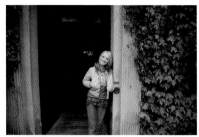

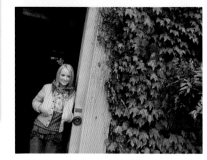

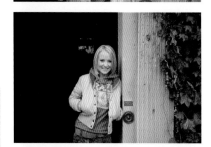

▲ Shot using the Auto White Balance setting on the camera, these images have a very cool tone, as the camera has struggled to find a white to neutral balance. In addition, there is a slight variation in image tone between the pictures, because of the change in crop.

DIRECT SUNLIGHT

It is difficult to take a successful picture in direct sunlight, because the contrast can be confusing – visually speaking. If strong sunlight is the only light available, use it as creatively as you can. Avoid, if you can, sunlight immediately behind the camera, as it will be flat (although sharp), and can make a portrait subject appear fatter. In addition, your model will have to squint, which is guaranteed to spoil the portrait.

WINTER LIGHT

Even though, on dull winter days, it can be frustrating to work in low light, it has a pleasing quality, and I always try to exploit it as much as possible before introducing flash or artificial lighting – unless for dramatic effect. The short days, of course, make it even more difficult, although the inherent specularity of the light makes for a natural, believable result.

When taking photographs outside it is important to set the white balance accurately if you want to avoid spending too much time on postproduction, especially when shooting JPEGs.

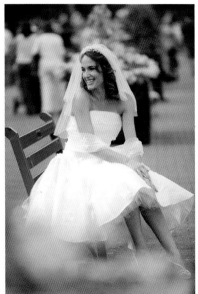

▲ Shot using Flash Balance. Even though no flash was used, these images feature a much warmer glow – a look we are accustomed to with film. All images are the same colour, with no deviation, due to the set colour balance.

◄ When sun is the main source of light, turn your model's body slightly away from it. This creates depth and helps form a shadow area. Getting the subject to look towards the light will exaggerate the brightness falling onto the face.

LIGHT AND THE LANDSCAPE

The secret to shooting landscapes in the right light is to avoid the middle of the day when the sun is high and shadows are shallow. This makes for a scene that is dull and lacking in contrast. For optimum results, shoot at the beginning or end of the day, when the sun is low in the sky and golden in colour.

THE GOLDEN HOUR

At either end of the day, when the sun is low and at an acute angle, the light is at its warmest, hence the expression 'the golden hour'. This, for most landscape photographers, is when the magic happens. The natural side lighting at this time of day allows the textures of trees and rocks to come alive, giving depth and detail to the photograph.

Backlighting during the golden hour is one of my favourite types of light, especially when shooting a mountain range or coastal scene. The golden light touches the mountaintops and any low cloud helps give the image even greater depth. Backlighting can also be used to create very graphic images, especially when the skies are deep in colour.

SOFT LIGHTING

Diffused sunlight is preferable when shooting a scene that, in any other light, would be too high in contrast. A typical example is the waterfall, where the reflections from the water can be extremely bright. In diffuse light, this effect is lessened and the exposure more balanced, therefore more detail is recorded.

When shooting in woodland or parkland, the lighting is often soft because the tree canopy reduces much of the top light. When shooting in these conditions, it's often a good idea to look for a colour, or to find a spot where there is dappled or back light, both of which will help to inject contrast into the composition.

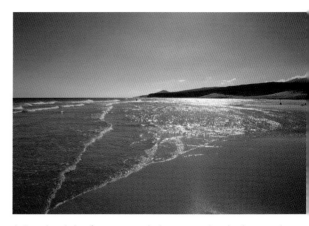

▲ *Even though the afternoon is not the best time to shoot landscapes, pleasing results can still be achieved – especially when shooting water. In this image, the sun reflecting off the sea brings texture and mood to the composition.*

HARD LIGHT

Bright sunlight can be a photographer's best friend or worst enemy in the landscape. Not only does it make accurate meter reading more difficult, but the increased contrast makes it harder to control shadow detail. When carefully controlled, hard light can contribute to dynamic images, for example, on the rock face of a mountain.

DAPPLED LIGHT

When strong sunlight falls through a tree canopy and leaves little hotspots of light on the ground, this is referred to as dappled light. Photographically, this injects life into the forest floor, thanks to the contrast created. In particularly strong sunlight, however, watch out for the highlights burning out altogether, as this is unattractive.

◄ *When shooting in the middle of the day, with sun at its peak, it can be difficult to obtain contrast and texture, so be prepared for flatter-looking landscapes with no real sense of scale.*

spotlight

Use a one-degree handheld reflected lightmeter for the most accurate readings when shooting landscapes.

EXPOSURE

If using a camera's built-in lightmeter, I would recommend using the spotmeter mode and measuring from the part of the scene where it is most important to record detail. This is also preferable when shooting in high-contrast conditions where the light intensities vary considerably.

When taking a spotmeter reading ask yourself whether the subject you are metering from is lighter or darker than an 18 per cent grey. If you can learn to see a scene in tones of grey you should be able to make any metering corrections instinctively. This comes with practice. Use a grey card or, better still, a greyscale card, to see and understand exposure compensation when on location.

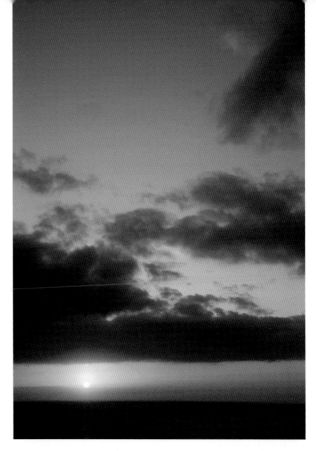

➤ *This image is a typical sunrise, with bright golden colours on the horizon deepening to deep blues at the top of the sky.*

▼ *Depending on how you expose your picture, dramatically different results can be achieved with backlighting, from very graphic images with intense skies and little shadow detail, to soft, pastel images with no real blacks or whites.*

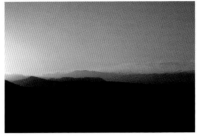

THE f/16 RULE

If in doubt about exposure on very sunny clear days, the f/16 rule is the place to start, and is a rule of thumb used by many landscape photographers. The starting point at ISO 100 is 1/125sec at f/16. From there, you can follow the reciprocity law and adjust your exposure to, say, 1/60sec at f/22, or 1/250sec at f/11 and so on.

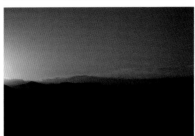

HDR

The best of both worlds – that is, a landscape that features both a deep, rich sky and full detail in the shadow areas – can be achieved by digital means. Simply make one exposure for the sky, a second exposure for the rest of the scene, and blend the two in a postproduction software such as Photoshop. HDR stands for High Dynamic Range, which is the ratio between the brightest and the darkest areas in a scene.

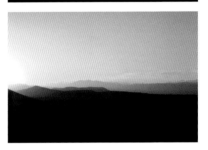

For the best results a tripod is essential. Make sure it is completely locked off, so the only change will be in the camera's exposure, and not in camera movement. Once you have composed the image and locked the tripod off, take one meter reading for the highlight and another for the shadow. For example, the first reading might be 1/125sec at f/16 for the highlights and 1/15sec at f/16 for the shadows.

▲ *Bracketing exposures in preparation for HDR.*

▲ *A sunset filter is useful for adding colour to a washed-out sunset.*

Now take a range of exposures, being careful not to adjust your focus or focal length. It's best to switch off the autofocus during this technique. Firstly, expose at your highlight reading of 1/125sec at f/16; then take mid-tone exposures at 1/60sec at f/16 and 1/30sec at f/16. Your final exposure would be 1/15sec at f/16 for the shadow areas. These images will then be combined later in Photoshop to produce one image, which can feature as much or as little detail as you like. (See also HDR blending, page 156.)

BRACKETING THE EXPOSURE

Another way to obtain the correct exposure is to bracket. This can be carried out manually or, if your camera has the facility, automatically. Portrait photographers rarely bracket, instead taking the time to make sure the exposure is correct from the off. That way, there is less risk of losing a potentially successful portrait to an inaccurate exposure.

Bracketing is achieved by making an exposure at what you believe to be the correct reading, then taking additional exposures either side, in third-, half- or whole-stop increments, usually up to one stop either side of the 'correct' reading.

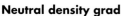
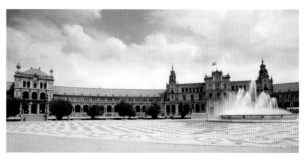

FILTERS

Neutral density (ND)

ND filters are a must for landscape photographers, as they allow for a slower shutter speed, which is particularly important when shooting moving water. Using a slower shutter speed on a bright day creates a streaking effect, or, if long enough, a glassy appearance.

Neutral density grad

Graduated ND filters are another essential tool for landscapes. They come in 0.3, 0.6 and 0.9, equating to an exposure reduction of one, two and three stops respectively. These filters can be adjusted within the filter holder to reduce the brightness in the sky so that it balances with the exposure for the foreground, but without affecting the colour in any way.

Polarizing filter

A polarizer is designed to cut out glare and reflections from wet or shiny surfaces, thus reducing distractions and adding depth. It can also be used as an ND filter, as it cuts the level of light hitting the meter.

Sunset filter

This is my favourite filter for landscapes; it can add intensity to a lacklustre sunset where the colour in the sky is not sufficient. The filter is an easy way to introduce a warm tone throughout the scene. However useful this filter might be, don't overuse it. In particular, avoid using it in the middle of the day – the position of the sun will fool nobody!

Red, orange, green and yellow filters

This collection of filters provides the perfect complement to black and white photography. The red filter is particularly dynamic, and darkens blues to almost back, while rendering – for example – clouds, pure white. The orange and yellow filters produce more subtle results. A green filter lightens skies and foliage but darkens any red or orange tones.

▲ A neutral density grad balances the exposure so can, for example, retain detail in the sky, which would otherwise be lacking.

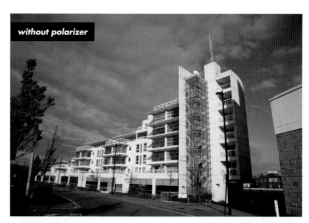

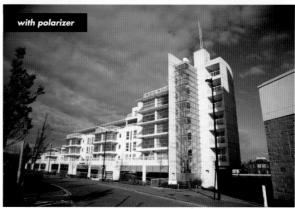

without polarizer

with polarizer

▲ When light hits a surface, some is absorbed, but the rest is reflected. Some of this reflected light becomes polarized and affects the colour of the image. A polarizing filter removes distracting reflections from water or glass, helps deepen the tone of the sky and defines foliage.

Think of window light as an immovable softbox. Its quality and direction can be controlled with the use of netting and drapes, in the same way as you might use diffusion material on a softbox.

When I arrive at a client's home the first thing I look for is a large natural light source, such as a window. This makes it very easy to just turn up and be shooting within minutes – perfect for executive portraits. With this all in mind, proper use of window lighting is a must technique to learn.

CAMERA POSITION

When shooting with window light, the photographer always needs to be aware that it is fixed, and therefore needs to move the subject and camera accordingly. The subject is best placed as near to the window as possible in order to make use of the level and quality of light; in other words, its exposure value and its sharpness. The camera position is then moved according to the shape of the light falling onto the subject, which is especially important in portraiture. For a full-face portrait where the sitter is looking straight into the camera, the camera lens should be parallel with the window, in order to create a 45-degree lighting pattern.

For a two-thirds portrait in 45-degree lighting, the camera should be moved away from the wall, further into the room. This maintains the shadow area on the face. If the camera was kept in the same position as for a full-face portrait, and the subject simply turned their face further towards the window, the result would be very flat.

GROUPS

To achieve a full-face portrait of a small group, the subjects should be moved into the room, a short distance from the light source. The camera position needs to be near to the window wall. However, by positioning the subjects away from the light source there will be a loss of exposure and – more importantly – a loss of sharpness and quality in the light. In this case it is best to place a reflector between the subjects and camera to bounce a little of the light back up on to their faces. This will help increase information in the shadow areas, as well as slightly sharpening the light.

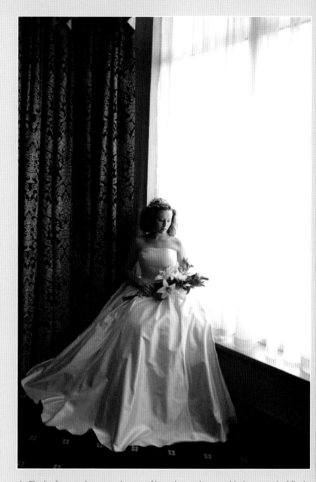

▲ Think of a window as a large softbox, but with natural light instead of flash.

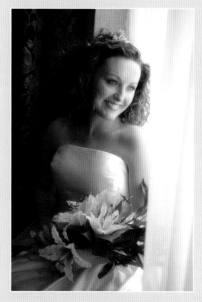

◄ When shooting portraits by a window, both model and camera should be as close to the window wall as possible.

> ● **spotlight**
>
> *Avoid posing the subject where they are looking into the room away from the light source.*

▲ The diffuse light picks out even the most intricate detail of a wedding dress and veil, as seen in this image.

SOFT LIGHT

When a window is softened by netting material, the effect created is similar to a softbox. This technique even works on sunny days, the only difference being a slightly sharper quality to the light – similar to removing a diffusion layer inside a softbox. Positioning a reflector in front of the subject and pointing it back towards the window so as to light the face, but not over-light the shadow side, can improve the result even further.

▲ By moving the subject further into the room, it is possible to reach the point where the light is feathered.

FEATHERING THE LIGHT

If the window is not softened in any way by material or drapes, the subject will need to be moved away from the light source and into the room. The best part point of any light – whether flash or natural – is the feather edge. This is the point between the very harsh light and the shadow (the former creates too much contrast, the latter not enough). Simply hold your hand out into the light and move it away from any light source to see the dramatic change in both level and quality.

◄ Direct light falling onto the subject will create a greater ratio between highlight and shadow, thus giving whiter whites and blacker blacks with very little tone in between.

◄ Moving the subject slightly out of the light will give a better result as there will be increased information in the shadow areas and more detail in the highlights, making for a narrower lighting ratio.

◄ When the subject is in the slightly shady part of the window aperture, this is the perfect position for feathering. However, if the window is very recessed the shadows will again have little or no detail.

spotlight

Always carry a large white/silver reflector with you. When working inside with window light, it will become your best friend.

THE LIGHT

If your subject is facing into a room, towards the camera, with the light behind them, there will be little or no detail in their face – only a backlit effect, particularly if the light is strong. If you have taken a meter reading for the light, rather than the face, you will end up with a silhouette. If you have metered for the shadow areas, the image will be overexposed and will result in flare – which can be creative in its own right.

If, however, there is enough artificial ambient lighting in a room, a silhouette will not result as the artificial ambient light has an impact on exposure, lifting shadow areas and bringing detail into the subject.

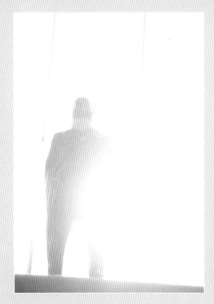

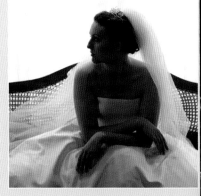

▲ Flare is a result of shooting into the light and exposing for the shadow areas.

▲ If there is enough ambient light in the room, it will balance with the natural light, bringing detail to the foreground.

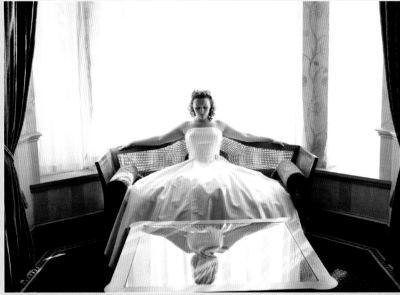

▲ Use the light to your advantage for added drama.

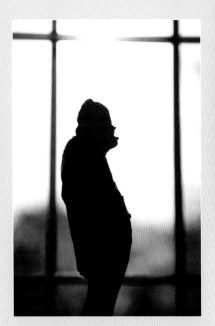

▲ A silhouette results when the meter reading is taken from the light source.

spotlight

To record detail in a subject who is facing into a room, use a reflector or fill flash in order to obtain a working aperture.

MULTI-DIRECTIONAL LIGHT

A bay window provides opportunities for quite dramatic effects, as the light comes from the sides as well as behind. This is the sort of lighting that might be used for capturing the physique of a sportsperson. However, for more general photography you should ask your subject to look down or to the side, rather than at the camera, otherwise you'll have to use fill flash, which would be a shame as it defeats the object of the dramatic light.

PHOTOGRAPHING GLASS

Taking pictures against the light is an ideal approach when photographing something like glass; in fact, anything slightly transparent will benefit from being set up with the light source coming from behind.

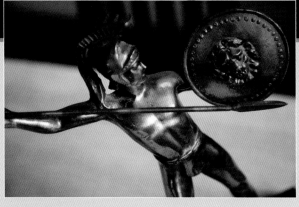

▲ Venetian blinds directed onto the subject increase sharpness and give more reflection in the highlights.

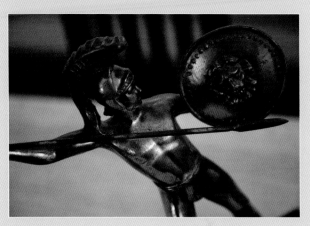

▲ When tilted to bounce light from a ceiling or wall, Venetian blinds give a much softer light, reducing the reflections.

SHAPING THE LIGHT

Venetian or slatted blinds offer further opportunities for creative light control, and are particularly effective when photographing nudes or still life. On very sunny days, with the light streaming through, the striped effect can be eye catching. If they are tilted so that the light falls on the subject, the effect is more dramatic. Tilt them to cut out the light, on the other hand, and the result is much softer. Metal or white blinds reflect the light back on to the ceiling and therefore bounce the softer light around the room.

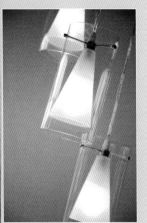

◄ These lampshades were lit by a window to the left, which created a highlight on the glass cylinder. A white reflector on the opposite side gave another reflection, which emphasizes the cylindrical shape. The lights were switched on to complete the exposure. It was essential to shoot at the right time of day to make the most of the soft window light. It would have been much quicker to set it up in the studio with a softbox instead of in the client's showroom. I did, however, cheat by using low wattage bulbs to avoid hotspots.

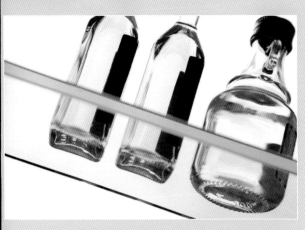

▲ For this shot I supported a glass shelf on some boxes in a window, then simply positioned the bottles on top, incorporating the glass shelf into the composition. I took a spotmeter reading from the liquid and opened up by two stops to increase brightness.

USING REFLECTORS

A reflector is a must for any photographer, whether working on location or in a studio, shooting portraits or products. A reflector bounces or diffuses the light source to enhance the photograph, and can be anything from a white wall to a compact mirror. Its ability to reflect light is limited only by its reflectance. The shinier the surface, the more light is reflected, therefore a reflector made of silver fabric bounces back more light than one that is white. At the same time, it sharpens the specular nature of the light.

REFLECTOR TYPES

A reflector can be as simple as a piece of white card or a white wall. I use the foldaway types made by Lastolite, which are quick to open and take up little room. Their effects vary, as they come in different styles, sizes, colours and materials.

On a cloudy day I use a silver or sunlight reflector as this sharpens and slightly warms the light. This same reflector can also be used on sunny days but, because of its mirror-like reflectance, the result is rather harsh so should only be used if a dramatic result is desired. It is also useful for strengthening the light falling onto a subject who is indoors and some distance from a natural light source, such as a window.

Large reflectors usually come as a rectangular panel, which makes them easier to manage. The most popular reflectors are a disk shape, and are small to store. To my mind, the most efficient reflector is the Tri-Grip, which is triangular in shape and has a handgrip for ease of use.

If I am working alone I use the small Tri-Grip reflector, which is basically a reflector with a handle, making it easy for me to hold and direct the light onto the subject. If I am working with an assistant I use the larger Tri-Grip as the assistant can stand further away and reflect more light. As a result, it's ideal for lighting small groups as well as architecture.

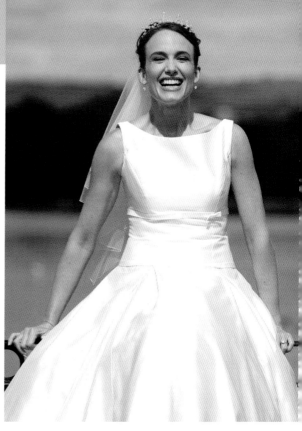

▲ *Without diffusion reflector.*

➤ *Position the diffusion reflector between the subject and the light source, in this instance above and to the right of the camera. With the diffusion reflector in place the image is softer overall and the lighting much kinder to the subject. Because the reflector has cut nearly two stops of light the image is quite high key. This is a common fashion lighting trick on location.*

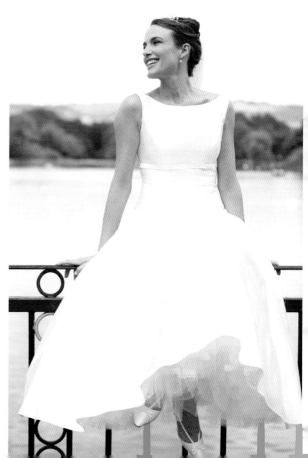

HOW TO USE

A reflector is simple to use. It is best placed in front of the subject to bounce light back from behind or to the side. It lifts shadows in a way that appears natural, and can provide just the professional finishing touch your pictures need.

For a soft, natural result when the sun is falling directly onto the subject, use a large diffusion reflector placed between the subject and the sun. This will soften the harsh light and will help prevent a subject squinting.

▲ When working alone, a Tri-Grip reflector can be held with one hand to direct the light under the chin and eyes without the need for assistance, stands or supports.

▲ When using a portable flash system fitted with a diffusion reflector and then diffused even more through a large diffusion reflector, the results are almost as soft as those taken with a studio flash and softbox.

s p o t l i g h t

In extreme circumstances a black reflector can be used to deaden and cut the light from one side or above. This is called subtractive lighting; the technique also increases the modelling on the face if the lighting is soft and muddy with no specularity.

PROFESSIONAL HINT

Use reflectors with a variety of tones and colours for different effects:
White *For very sunny climates when a soft reflection is needed*
Gold *To give an exaggerated warm feeling*
Silver *To give a mirror-like reflectance*
Sunlight *A slightly warm glow*
Sun fire *Warm and specular in highlight areas*
Black *To subtract light and create modelling*

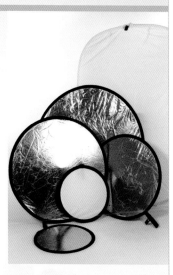

s p o t l i g h t

Avoid placing a reflector opposite the light source as this appears unnatural – as if the light is coming from two directions.

▲ These two images show the dramatic effect a reflector can have on an image when working in the shade on a sunny day. The image taken without a reflector (above left) was exposed for the ambient light, which gives a good result. However, the second image (above right) was exposed for the sunlight reflected onto the subject. This use of a reflector is just like pointing an off-camera flash or spotlight onto the subject.

ARTIFICIAL LIGHT OUTDOORS

Shooting city lights at night introduces a fresh dynamic to your portfolio – and is a useful exercise in mastering shutter speed. The dead of night is not always the best time to shoot in the city, unless you particularly want black skies. Instead, set up your shots just before dusk, when the lights are on but there is still a hint of blue in the sky. The results are much more vibrant.

STREET LIGHTING

With all night-time images long exposures are a given, so a tripod is essential. It is also a good idea to use a cable release to avoid any camera shake when releasing the shutter. When using street lighting as the main source of light, be aware of the overall image and how any lights in the background will appear. Be especially conscious of their brightness, as any light coming from behind you always appears twice as strong.

▲ *Avoid setting the camera to auto balance as it will correct any strong colour in the picture.*

NEON

Neon is inherently green in colour but, of course, with correction filters or white balancing in postproduction can be turned back to white, giving a magenta cast to the scene.

CITY LIGHTS

By shooting when the sky is still blue (up to about 20 minutes after sunset) the image's overall contrast is enhanced by the information in the shadow areas of the composition. The overall mood is maintained, with the movement of people and traffic.

TRAFFIC LIGHTS

Traffic lights lend themselves to long exposures by creating streaks of orange and red within the scene. The combination of traffic lights and a cityscape is dynamic but deceptively simple to achieve. Experiment with a variety of shutter speeds to increase or decrease the streaks, but be quick, as the blue in the sky will soon fade to black.

▲ *Use a grey card for quick colour corrections either in-camera, by setting custom colour balance, or during postproduction.*

EXPOSURE

If using your camera's TTL meter, set it to spotmeter mode and take your reading for the most important element of your composition. Bright floodlights can fool a camera's TTL meter if it is set to centreweighted or average exposure mode and the results will be underexposed. You'll soon get into the habit of compensating for the camera's mistakes. Remember to meter from a mid tone for accurate results with the spotmeter, but be aware of burning out any highlights.

Don't try and avoid using a tripod by increasing the ISO – try to stay within the ISO 100 to 400 range in order to keep any noise to a minimum.

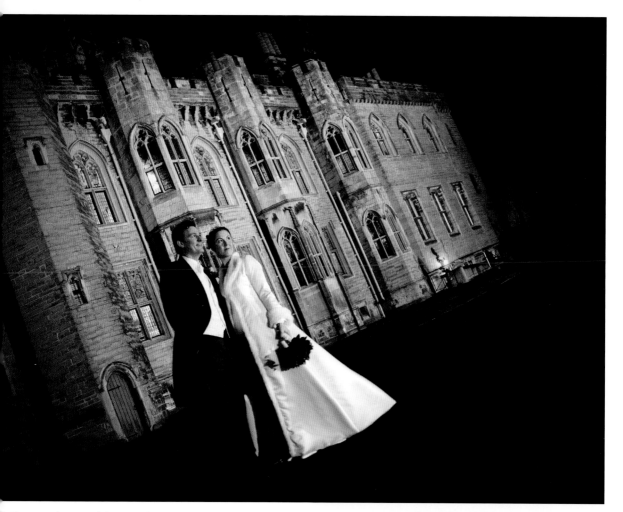

Shooting with tungsten lighting out of doors is simple with digital, as the colour balance can be changed either in-camera or during postproduction, resulting in natural flesh tones.

spotlight

Check your histogram for any burnt-out areas, which will give clipping when printed.

Click balance corrected in Photoshop.

Shot using just the neon light for illumination.

MIMICKING STUDIO FLASH WITH NATURAL LIGHT

It is surprisingly straightforward to manipulate natural light so that it mimics the shape and quality of studio lighting patterns. The use of reflectors is key to this technique. When working on location, whether in a client's home, or indeed in any room, head for the window light, as this will be easy to manipulate whether it is diffused or not.

THE 45-DEGREE ANGLE

The 45-degree angle is popular with both portraits and product shots. The position is strong and directional, allowing the light to cross the subject, creating a highlight side and a shadow side. The shadow gives the subject depth, resulting in a three-dimensional appearance.

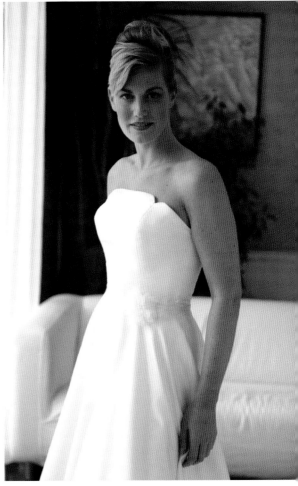

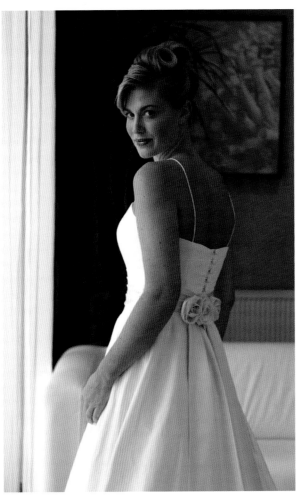

▲ *If the subject is positioned in the middle of the window a split lighting pattern is achieved. Split lighting is more commonly used with male portraits as it creates a stronger body shape due the light being from one side. The other side of the body is in shadow and, if the sun is harsh, the lighting pattern is exaggerated, creating a more powerful contrast. In this portrait the net curtains soften the window light at source. To open up the shadow area a little, a white reflector was positioned on the subject's shadow side. Be careful not to overdo any reflected light on the shadow side as this can make the image look unnatural – as if the light is coming from two sides. This is quite common when using silver or gold reflectors.*

◄ *In order to create a perfect 45-degree lighting pattern on a model's face using window light, the subject and camera have to be positioned carefully, as the window cannot be moved. The angle of the light should illuminate the five planes of the face: the forehead, both cheeks, the chin and the nose. This lighting pattern is considered to be the most flattering because it gives the features shape, and the shadow helps create an illusion of slimness. In this portrait the subject is positioned to give a two-thirds narrow lighting pattern. This means that the part of the face that is lit is least visible to camera; the side of the face closest to the camera is in shadow, which makes the subject appear thinner. This lighting pattern means that the viewer is drawn to the highlight areas first, and thus into the portrait as a whole.*

Choose the right reflector for the right effect, not forgetting a diffusion reflector to soften the sunlight falling onto the subject if it is particularly harsh.

➤ To achieve a flat lighting effect the subject should be placed directly in front of the window, so the camera is between it and the subject. The overall illumination is referred to as flat lighting, as both sides of the face are lit evenly, with neither being lighter or darker. To achieve a pure flat-lit portrait, a reflector needs to be placed under the model to bounce any light back into the face.

◄ Using natural light to create a spotlit effect indoors requires a sunny day. The subjects should be placed some distance from the light source and a highly reflective surface – such as a silver Lastolite Tri-Grip – should be used to bounce the harsh sunlight deep into the room. The effect is instant and striking. In this image the shadows are pushed upwards because the reflector was placed on the ground near the window. If the window is very large, however, a reflector can be used above head height in the window to change the direction of the reflected light and hence the angle of the shadows.

Flora is always a popular subject with photographers. Whether your picture has been commissioned or is just for fun, the rules are still the same: contrast (or lack of it) will make or break the photograph. Most photographers start by shooting flowers and fauna in direct sunlight and on location, and usually with the most unusual or colourful flowers found in the garden or encountered while out for a walk.

▲ Sparkling highlights suit reflective surfaces.

SUNLIGHT

Strong sunlight is the perfect complement to very reflective surfaces, as it picks out highlights on the subject and gives a sense of depth and texture. Remember to give the light direction either by moving the flower slightly or moving camera position.

If strong sunlight is creating too much contrast upon a delicate subject, a diffusion reflector, which removes one or two stops of light, can be used to diffuse and soften the result.

SHADE

Shade is preferable for some plants, especially those which are light in tone and have a delicate texture, as soft light allows the gentleness of the plant to come through. To give the light direction without losing the delicacy of a plant, try using a very small mirror – it's ideal for reflecting a small spot of light and is even sharper than a silver reflector. It can be used for very small, specific areas to help achieve depth and texture.

▲ The denseness of foliage and the multi-directional light can make a scene such as this difficult to expose for.

WIDER SCENES

When lighting a scene of flora, such as in a greenhouse, very little can be done without the introduction of multiple flashes to add accents or fill in shadow areas. Reflectors can be a help with picking out elements close to the camera but they are difficult to hide, as foliage is generally dense and lets little or no light in. Multiple flashes, however, are quite effective, especially when triggered wirelessly as the small flashguns can almost be hidden anywhere.

▲ Softer tones benefit from diffusion.

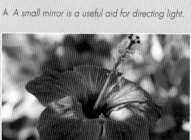

◄ *Daylight can be manipulated in many ways. In this case, the result is soft and muted.*

▲ *The flower in shade is soft and a little flat.*

▲ *A small mirror is a useful aid for directing light.*

BACKLIGHTING

Leaves with a vein pattern benefit from backlighting, as it brings out their texture. Even on dull days, backlighting can be achieved by photographing in darker situations where just one shaft of light touches the leaf or plant. The shadow area in the foreground then acts as a tunnel.

WINDOW

Window light is always at hand, and is my preferred starting point. If photographing a flower, for example, try moving it closer to or further from the light in order to alter the quality of the result. To emphasize the delicacy of a leaf or petal I often turn the flower so its back is to the light, as the translucence is very pleasing. If the flower's petals are very thin, the result is often appealingly soft and low in contrast, as the petals cast very little shadow on each other.

▲ *The flower, complete with mirror reflection, now jumps out of the picture.*

▲ *When shooting macro in daylight use a reflective surface, such as a piece of white card or tin foil, to introduce some illumination onto the subject.*

➤ *When a structured plant, such as this cactus, is lit by strong sunlight, the increase in contrast enhances the dynamism of its shape.*

▲ *The sun streaming through from behind creates layers of light, shape and tone.*

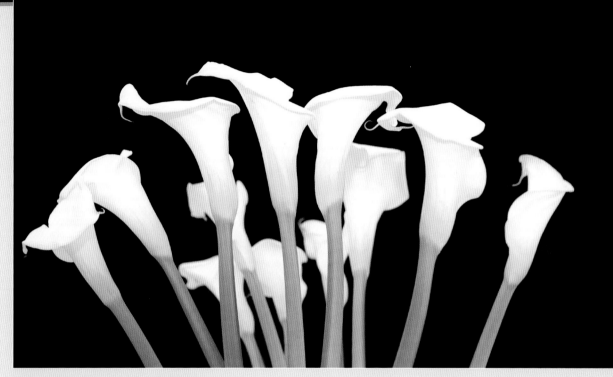

▲ *Tungsten lighting is easily accessible and versatile.*

TUNGSTEN

When working inside tungsten light is all around us, so it's a quick route to different lighting effects for flowers. Low-voltage down-lighters are my favourite as they give a strong, directional source and a generous level of light to allow for faster shutter speeds and smaller apertures, giving a greater depth of focus to the image. I usually take a grey card photograph and then set a custom colour in-camera, even when shooting in RAW, as it is useful to see the tones of the arrangement or subject, especially with translucent petals or leaves.

RING FLASH

Ring flash goes hand-in-hand with macro photography, as the flash – which encircles the lens – produces a very soft shadow edge evenly around the subject. I use a ring flash adapter on my Speedlite for this kind of photography as it is lightweight and softer in quality than a macro flash (which is a purpose-built flash with small flashbulbs around the edge of the lens). The benefit of the Speedlite attachment is that it can be used for more than just macro photography.

spotlight

When shooting with flash don't be afraid sometimes to over-light a flower from behind, as this can emphasize the delicacy of the plant and its pastel hues.

▲ *A soft outline, giving a three-dimensional result, is what characterizes ring flash photography.*

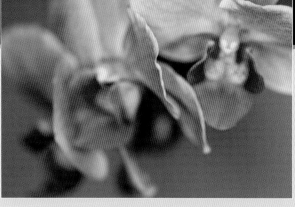

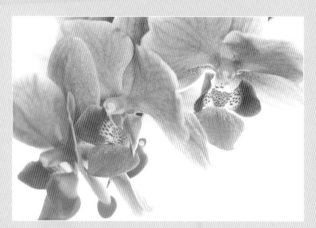

▲ Macro flash is great for real close-up work. Like a ring flash, the flashguns encircle the lens for even illumination and soft shadows. Close-up flash always gives punchy colours with high saturation.

STUDIO FLASH

I generally only use studio flash when shooting flora if I am required to give exact contrast and a specifically coloured background, or if the flowers are going to be cut out for web or design purposes. When shooting down on a subject I usually use a piece of glass to support the subject and then light the background underneath separately. This is different from, say, shooting a subject on a coloured background, which would create shadows on the paper or cloth. By lighting the subject and background separately I can quickly change the coloured paper of the background or simply add gels to the background light to create washes or mixes of colours.

▲ In this second shot I introduced a second flash behind the flowers to light the wall and give the petals a degree of translucency. The strong colours are thus softened to a more delicate pastel.

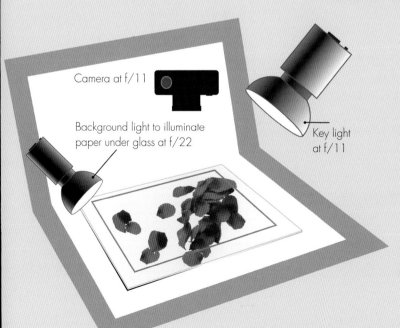

Camera at f/11

Background light to illuminate paper under glass at f/22

Key light at f/11

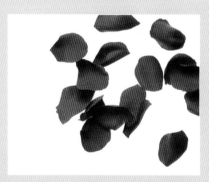

▲ By separating the subject (in this case, the red rose petals) from the background with a sheet of glass, you have the option of changing the background colour easily.

WORKING IN CONFINED SPACES

When shooting in confined spaces, make use of any available ambient light. This may come in the form of a small window, a room light or even torchlight. Flash should be considered the last resort. The secret to working in restricted locations is to make the best out of a bad situation.

REFLECTED LIGHT

When using ambient light – whether daylight or artificial – look for anything, such as mirrors or chrome work, that might be a suitable surface from which to reflect light and therefore brighten the overall scene. If there is too much light in the scene then, of course, look for ways to block it out. Use a window blind or drape to narrow the light, and use your hand or a book to shade any small objects. You can even use your body as shade simply by standing between the subject and the light source.

▲ The varied colours used in stage lighting are a creative tool in their own right.

▲ A wideangle lens is my first option when shooting in confined spaces and making use of any available light. Shoot into the sun, if need be, to introduce an element of drama into the image. This image makes full use of the ambient window light and the white wall reflects even more light back on to the subjects.

CORRIDORS

Corridors are a typical confined space. During wet-weather weddings, when I am forced to shoot inside, some hotel corridors can be quite effective as locations, particularly if they are flooded with light or dramatically dark with highlights from spotlights or picture lights. If there is not enough light to give drama to an image I often get permission to open up a doorway to one of the rooms, which creates a natural spotlight into the scene and becomes a light source in itself.

▲ If a background is distracting move closer to the subject, or use a longer lens for a tighter crop. This means that any natural light will fall on the subject instead of contributing to a messy backdrop. For greater impact, use a dark vignette filter on the lens or apply a vignette in postproduction; this forces the viewer's eye to the lighter areas of the portrait.

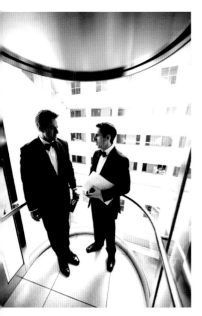

▲ When shooting in an elevator there is little option but to use a wideangle lens. I prefer to use natural light – if there is any – making postproduction adjustments in Photoshop to add contrast and drama.

▲ A window or white wall in the background of a candid portrait adds contrast. If it's necessary to use a high ISO, this contrast helps distract attention from any noise.

▲ Shooting a scene reflected in a mirror is a good way to give the illusion of space. Make use of any ambient light to frame the mirror itself.

COMBINED LIGHTING

Mixing artificial and ambient light is not a difficult technique to master. The most important decision concerns which is to be the dominant light source – the artificial, or the natural – for colour balance and skin tone. Usually, you would choose the light source that dominates the majority of the composition, but this is best left until postproduction from a RAW file in order to leave you with a choice.

PORTRAITS

When shooting portraits under mixed lighting conditions it is preferable to keep the skin tone as natural looking as possible. If lit by tungsten and balanced for daylight the subject's face will appear very yellow – an acquired taste by anyone's standards – so position the subject nearer to the white light source or use a reflector to kick more natural light onto their face. If tungsten light dominates the room, and you decide to use white balance to correct it, any natural light visible – such as a window or anything touched by the light from it – will take on a blue cast.

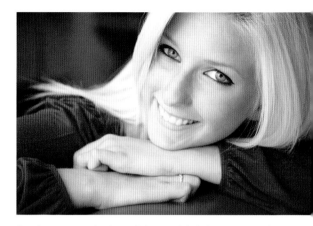

▲ When mixing artificial room lighting and daylight in a portrait, place your subject as close to the natural light source as possible. The quality of light is better, and the resulting skin tones will appear natural. The use of a reflector brings life to the eyes.

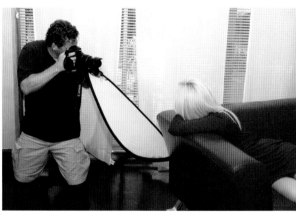

▲ To bring out the eyes and give an overall illumination to the face, use a reflector in one hand, making sure to tilt it back towards the window for maximum reflected light.

spotlight

When using reflectors in a room be careful not to bounce any tungsten lighting back onto the face. It's an easy mistake to make, especially when using spotlights.

◄ When a subject is touched by natural light, any colour correction is minimal, as in this image. His face is lit by a window, so is automatically the correct colour. This allows the warmth of the church interior to come through.

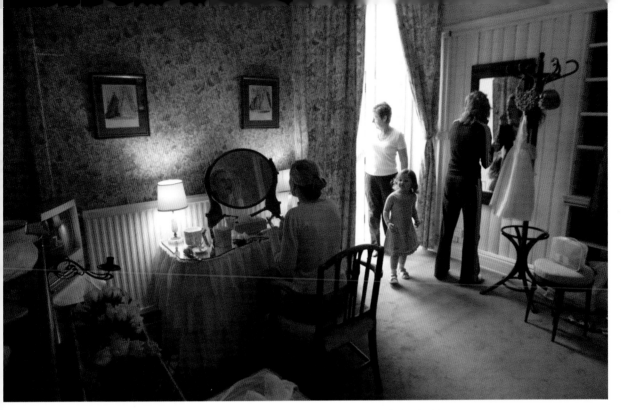

▲ This image is dominated by tungsten lighting but, to retain a sense of warmth, it has been balanced for the daylight.

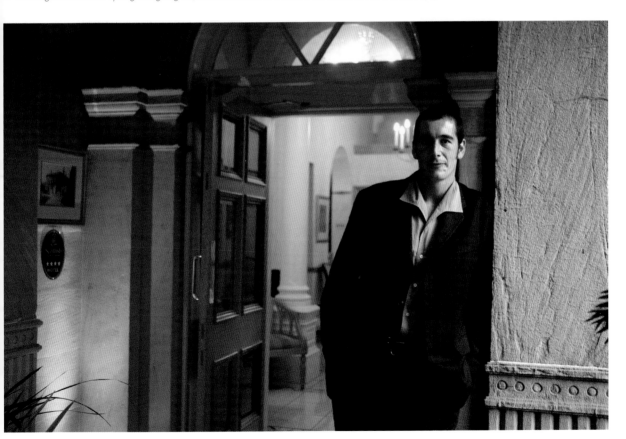

▲ Mixing ambient light is not a problem, but it is always best to try and light the face with daylight, for a more natural skin tone.

Whether shooting for yourself, or for a client, the secret to good still life photography is always to keep it simple. Lighting choice is quite a personal thing, and it can be soft – bringing out detail in the object you're photographing – or harder and more defined.

▲ Glass is best lit from the sides or from behind. To keep this shot simple, I placed the glass owl on a glass shelf and placed a room light underneath to illuminate it from the bottom. Of several images, this was the most successful, as I placed a piece of paper just behind the ornament to create opacity.

▲ You can't get much simpler than this shot – just don't tell my client! These onion-shaped ornaments were placed on a piece of white Perspex and then lit by a small window in the studio. This was in shade, so the lighting is very soft. I took several shots; some with a small reflector, and others using a mini mirror – both to lift the shadow detail a little. However, no prizes for guessing which one the client bought!

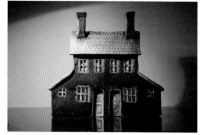

spotlight

Use a tripod when shooting in low light to avoid camera shake and to give you the option of using a small aperture.

▲ A small, low-voltage table lamp emits a sharp contrast light. It was used in this image to give the impression of street lighting, and to create separation between the ceramic house and white wall. I lit a tea light just inside the house for extra illumination and a cosy feeling. Finally, the image had some of its colour cast removed in postproduction.

▲ This picture was shot using available daylight coming through a window to the bottle's left. It was quite late in the afternoon, so although the light had all the warmth I needed, it was lacking in quality. I chose to shoot with a wide open aperture as I had no tripod. The lack of depth of field, and a boost of contrast and saturation in postproduction, helps the image.

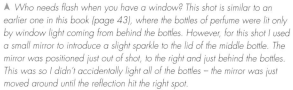

▲ Who needs flash when you have a window? This shot is similar to an earlier one in this book (page 43), where the bottles of perfume were lit only by window light coming from behind the bottles. However, for this shot I used a small mirror to introduce a slight sparkle to the lid of the middle bottle. The mirror was positioned just out of shot, to the right and just behind the bottles. This was so I didn't accidentally light all of the bottles – the mirror was just moved around until the reflection hit the right spot.

▲ This is a grab shot taken at a fruit market. The light was coming from an open roof, hence the top highlights on the peppers. This image sells time after time through photo libraries, but before submission it needed a slight increase in contrast and saturation, as colours tend to fade a little in CMYK printing.

◄ Lit from behind to increase the translucency of the glass pebbles, the image simply needed a low-voltage spot on the table behind the vase. The colour and extra contrast was created at the RAW processing stage.

COMMON PROBLEMS

When taking photographs in situations where natural light and artificial light combine, there are several problems you may encounter. First of all, the levels of light may be poor, and the colour of the light source difficult to work with. In addition, there is the possibility that any reflected light within your composition will appear unnatural.

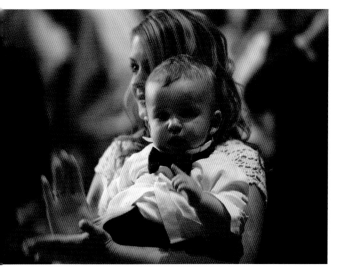

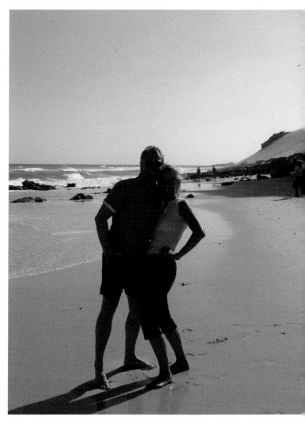

▲ **PROBLEM** *While overhead artificial light can be useful for illuminating a scene, the resulting shadows are cast downwards. This is unattractive, particularly with portraits, as it masks the subject's eyes.*

SOLUTION *Either ask the person to look away from the camera – if that suits the sort of photograph you are aiming for – or use a reflector to bounce light back into the face, positioning it just in front of your subject, and pointing upwards to fill in any shadows.*

▲ **PROBLEM** *When shooting into the light with the camera set to automatic there is a good chance that something like this will be the result. This is because the camera will have exposed for the general scene, not the subjects (who are smaller in the frame), leaving them underexposed.*

SOLUTION *Set your camera to spotmetering mode. This will take an accurate reading from the focus point – the faces in this case – and therefore will result in a correct exposure. Some cameras have a built-in pop-up flash that offer an alternative resolution by adding a little fill light to the subjects.*

▶ **PROBLEM** *If your subject is some distance from the light source – such as with this example, where the child moved away from the window light – both the level and the quality of light becomes poor, and the result is muddy, with little or no contrast.*

SOLUTION *Keep the subject close to the light source but out of any direct harsh sunlight, as this causes its own problems.*

◄ **PROBLEM** **PROBLEM** By posing your subject too far into a wooded environment, the light will not only lack contrast, but also take on a colour cast.

SOLUTION Keep the subject close to the front of the tree line and look for an opening in the canopy of the trees above. Both these elements will help create a portrait with the right level and quality of light, and with no colour cast.

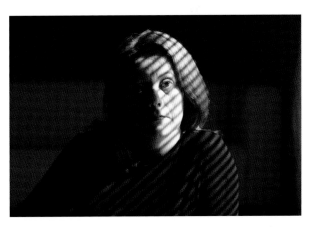

▲ **PROBLEM** When shooting an environmental group portrait it can be difficult to light the whole group evenly. This is particularly problematic during bright, sunny days, where the sun falls on some members of the group, and not on others.

SOLUTION Arrange the group with their backs to the sun. Watch out for flare, which degrades the image; expose correctly for the face and use fill flash or a reflector to improve sharpness.

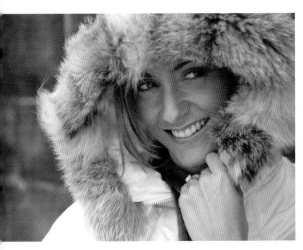

▲ **PROBLEM** Blur can be a common fault when working in lower light levels without a tripod. The effect of wind on textiles such as fur will, of course, also result in blur when shooting at slow shutter speeds.

SOLUTION Use a shutter speed at least equal to the focal length of the lens (e.g. 1/60sec on a 50mm lens, or 1/125sec on a 150mm lens). A tripod prevents camera shake or, if you shoot handheld, try an image stabilizing lens, whereby sensors within the lens neutralize any movement. Flash will further freeze the action.

▲ **PROBLEM** Dappled or speckled light is not a problem until you ask a subject to look directly into the camera, which causes the effect to be exaggerated. Unless deliberately being used for creative effect, the portrait loses any subtlety.

SOLUTION Ask the subject to look away from the camera to disguise and lessen the striped or dappled effect.

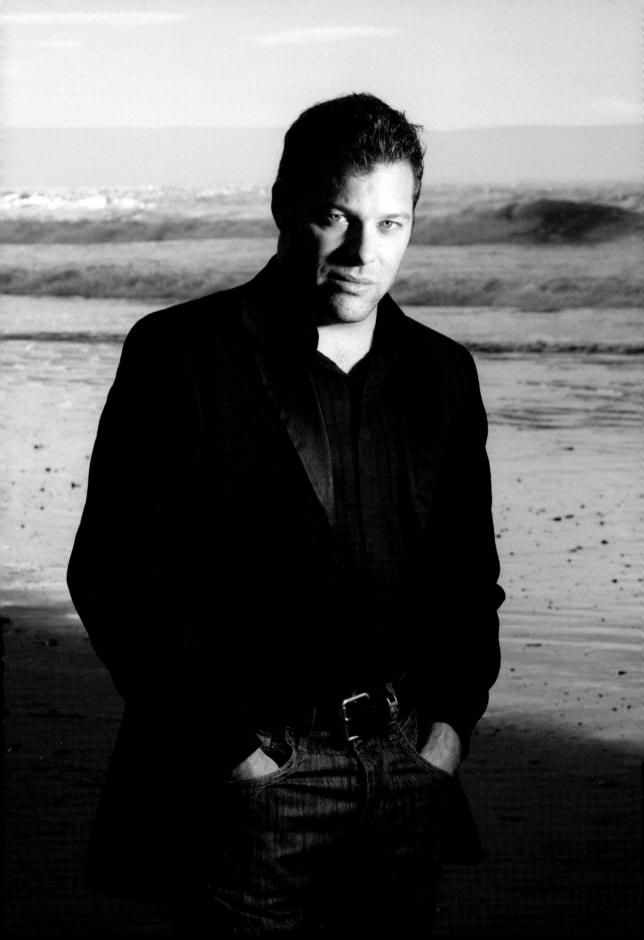

FLASH
PHOTOGRAPHY

UNDERSTANDING FLASH

Using flash can be one of three things: a get out of jail card in tricky lighting situations or difficult surroundings; the opportunity to open up a new creative side to your photography; or a real headache which, when used incorrectly, can take over your image.

In this chapter we look at the various different ways of using flash, both for everyday applications and for more complex set-ups. There are three types of flash: on-camera, portable and studio. Each does the job of illuminating the subject, but with drastically different results. Nearly all on-camera and portable flash units can be controlled via the camera to operate in an automatic mode. However, your results will be far superior once you start to take manual control of the unit's output – as well as of its shape and direction.

➤ *Strategic use of flash opens up a whole new range of creative possibilities.*

▼ *Mastering flash is one of the most satisfying ways of manipulating and controlling light.*

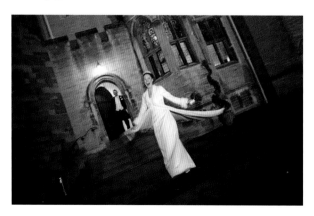

THE BASICS OF FLASH

Nowadays, the technology utilised in both on-camera and portable flash units is so sophisticated the need to work out guide numbers is a thing of the past.

GUIDE NUMBERS

Guide numbers today are more likely to be used to compare flash unit power outputs when purchasing than for determining the working aperture based on a formula.

A flash's guide number indicates how much power the flash will emit in relation to a standard film speed; the higher the guide number the more powerful the flash is. The flash's guide number will be stated by the manufacturer. To translate, the guide number, divided by the distance the flash has to travel, will equal the f-stop. This allows you to work out the flash distance based on ISO 100.

For each film speed, when the film speed doubles, the guide number changes by a factor of x1.4. When the film speed is halved, the guide number changes by a factor of x0.7. Guide numbers will differ according to whether being measured in feet or metres.

Guide number/distance = f-stop at ISO 100

INVERSE SQUARE LAW

Flash power diminishes as the subject moves further from the flash, according to the inverse square rule. However, fall-off is greatly reduced at the same time. A subject close to the camera receives a stronger, more focused light. As they move away, the flash spreads, losing its harshness; hence there is less fall-off, thanks to the greater spread.

The inverse square rules states that if a subject is twice the distance from the light source, they will be lit by a quarter of the illumination. In basic terms this means that if a subject moves from three metres from the flash to six metres, the flash needs to emit four times the amount of flash if you are to maintain the same aperture.

Basically, this means the further the subject is from the flash, the wider the aperture required – otherwise you will run out of flash power. Automatic flash takes care of most of the headaches, but once you start to progress with your flash-lighting skills you will need to grasp these basic principles in manual flash mode.

FALL-OFF

With a very narrowly focused beam of light the fall-off is greater. Therefore, when using a flash's zoom function, you can control the spread of light for a more focused beam. For a softer result, use the wideangle diffuser; this will spread the light, giving less fall-off or vignetting. However, the trade-off with this technique is the need for a wider aperture as the flash power is diminished.

▲ *When you are working close to the subject, the same rules apply if the flash is on-camera – as with this ring-flash image.*

To reduce the quantity of fall-off, try to keep the subjects as close to each other as possible from front to back rows, as even a small gap will result in a decrease in intensity of light, leaving those further away from the camera underexposed.

However versatile a flashgun such as this Canon Speedlite 580EX might be, there are still certain factors that must be taken into account in order to obtain the best possible results.

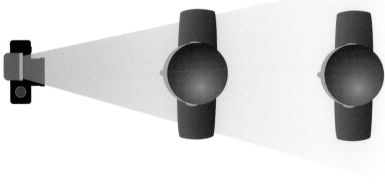

A subject twice the distance from the flash will receive a quarter of the power.

HOW A FLASH WORKS

Through the lens (TTL) metering is now a standard feature on almost all digital cameras. Combine this with a dedicated TTL flash and high standard, professional-looking results are easily achieved.

UNDERSTANDING TTL

Mastering flash provides the perfect opportunity to add another string to your photographic bow, and TTL metering allows you, for example, to capture subjects against reflective backgrounds with the perfect exposure.

TTL flash has an automatic metering facility that stops it from dominating the scene when combining it with ambient light. A non-TTL flash, on the other hand, dominates the image, resulting in a brightly lit subject and very dark background.

TTL flash is measured from the film plane, so meters in real time. This automatically gives the correct exposure, leaving the photographer to worry about getting the picture instead of fussing around with output settings. The next step up from TTL is E-TTL, or evaluated through the lens metering. As with TTL, this measures the flash output automatically, but combines this with multiple metering from different points in the composition, as well as measuring for the ambient light and pre-flash. These readings are then combined to give an even more balanced and natural appearance to both subject to background.

SPEEDLITE

I use a 580EX II Speedlite with my Canon EOS 5D, which, at the time of writing, was Canon's latest Speedlite, and features the E-TTL II proprietary automatic flash exposure control system. By using the multiple metering zones to measure both ambient light and pre-flash, then comparing the two and taking metering distances into account, this sophisticated system automatically adjusts the flash level to achieve natural results with good exposure of both background and subject. Even when the background is highly reflective, the E-TTL II can use distance information from the lens to eliminate underexposure.

➤ *Fill flash is used to help illuminate the shadow areas on sunny days, or to balance the subjects in a backlit scene, or where the background is brighter than the subjects.*

▲ *This automatic setting fires a pre-flash to evaluate the scene and subject to decide upon the best exposure.*

When the camera is set to a multi-meter mode the exposure is more balanced than if it had been set to spotmeter. This is because it evaluates a wider range within the scene, resulting in a more natural image.

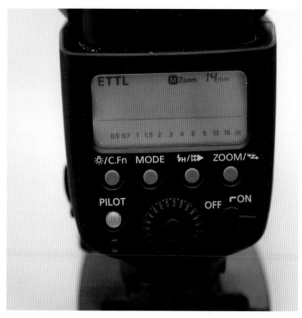

When a TTL or E-TTL on-camera flash is mounted on its equivalent camera body, the flashgun automatically receives information such as the lens's focal length, exposure control mode and aperture. It then makes adjustments accordingly, working together with the camera to achieve the most natural possible exposure.

Get to know your on-camera flash – don't always opt for the automatic setting. The flashgun can be 'told' to output all its power by setting it to manual, which is handy, for example, on a sunny day when the subject is some distance from the camera with their back to the sun.

PROFESSIONAL HINT

Experiment with your flashgun's settings so that you learn how much power they can emit. For instance, set the flash to full power, half, quarter, and eighth, then measure the exposure at a set distance of, say, four strides. As a result, in your hour of need you will have an exposure to work from.

If in doubt select TTL mode on the flash and allow the flash to predetermine the output itself. This works particularly well when exposing manually, or when the subject is close in automatic exposure mode.

The pop-up flash that features on many cameras is a useful little tool – and avoids the need for carrying an extra piece of kit – but its uses are limited at its output is low compared with something like a Speedlite or its equivalent.

IN USE

Pop-up flash helps with exposure in tricky lighting situations, such as bright sunshine or dark locations. The main problem with it is the power output, but, used appropriately, these little pops of flash will light subjects that are close to camera, as long as an aperture of between f/2.8 and f/5.6 is set.

The direction of light from a pop-up cannot be manipulated – it's straight ahead or nothing. However, the pop-up flash can be used to trigger other additional flashguns – or studio flash – when fitted with flash slaves (which receive a signal from the pop-up in order to trigger the flash). The pop-up on some more sophisticated DSLRs can be used to trigger additional flashes wirelessly, and can even act simply as a control that triggers the other flashguns or units without going off itself.

REDEYE

Because a pop-up flash is close to the camera lens, redeye can be a problem. Redeye occurs when the light from the flash strikes the retina, and is most common when flash photographs are taken in dark conditions, where the pupil is wide open and doesn't have time to close before the flash hits it. Moving the flash away from the camera reduces this problem, but, of course, this is impossible with the fixed pop-up flash. To help with this, many cameras with built-in flash come with a anti-redeye setting, which emits a flickering light that reduces the size of the subject's dilated pupils, thus decreasing the reflectance from the back of the eye. Other cameras have a little lamp that does the same thing by shining for about a second. While this system helps with redeye, it has its disadvantages, as it can cause your subject to blink when the actual flash fires, and also to lose the expression you had wanted to capture.

◄ Using pop-up flash can result in redeye, because of its proximity to the camera's lens. It is caused by the flash reflecting off the retina.

◄ Redeye can be corrected either by using the anti-redeye setting on your camera's flash, or later, in postproduction.

▲ Redeye can even occur when using sophisticated and expensive professional flash systems like ring flash – especially as a diffuser reflector, which helps the light spread more softly, doesn't soften ring flash.

spotlight

To help avoid redeye, ask your subject to look at a bright light for a few seconds before you take the shot, as this will close the pupil slightly.

▲ Pop-up flash is a quick fix method to freeze motion and illuminate subjects in a dark area.

TOO DARK

For the best results when shooting a group picture with pop-up flash, get as close as you can, as this will allow you to work with a small aperture. Realistically, however, with pop-up flash you are limited to a group size of five or six, no further than six to ten feet (1.8 to three metres) from the camera.

spotlight

Use a tripod when shooting in low light to avoid camera shake and give you the option of using a small aperture.

▲ Some form of inbuilt flash comes as standard on most compacts as well as entry-level DSLRs.

With a few tweaks of your camera's settings, pop-up flash becomes capable of being used more creatively. To do so, you will have to override certain functions, but gaining an understanding of the basic functions gives you the opportunity to be more creative with your photographs.

AUTO MODE

The camera will usually default to an auto flash mode, which will pop up the flash in low light situations. Many photographers keep this mode on, which allows them to concentrate on the image, allowing the camera to make the decision whether or not to use flash. This is ideal if you shoot from the hip much of the time as it is simple and almost foolproof.

FLASH ON

Using the flash on mode will force the flash to fire every time you take a photograph. The result is usually a flash-dominated subject, rather than one which blends ambient and flash. When shooting images where the subject is in front of a bright background or scene like water, or a reflective background, flash can be used to fill in the shadow areas. This is referred to as fill flash. Keeping the flash on also results in a highlight in the eye, making them sparkle, as well as lighting the eye sockets if the sun is above. Fill flash isn't restricted to portraits: it can be equally useful with still life and plant images. However, take care not to over-light the main subject, as this can appear artificial.

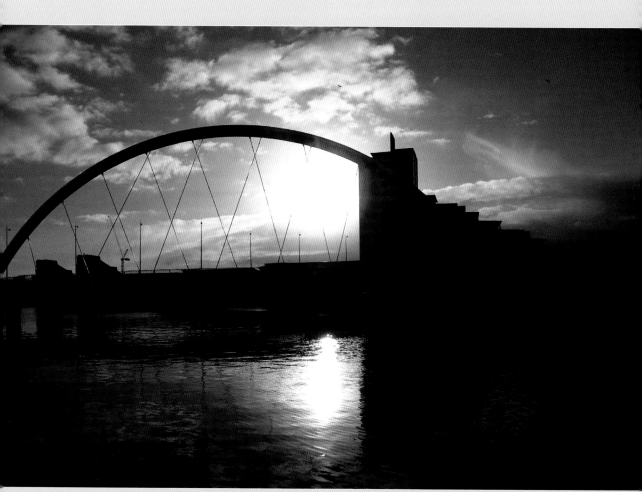

▲ When shooting architecture into the sun, turn off your pop-up flash, as it is, of course, too weak and far away to have any impact. For extra drama, this picture was exposed for the sky. If it had been exposed for the shaded side of the bridge, the result would have been a muddy bridge and white sky.

◄ Here, I switched off the pop-up flash, both to avoid it reflecting off the glass, and also to underexpose the objects on the sill so they didn't create a distraction.

▲ When shooting at a concert remember to switch off the pop-up flash, as all it will do is light the foreground – in this case, the heads of the people in the row in front.

▲ By turning off the flash the result is far more atmospheric. With such contrasty lighting, a spotmeter reading was vital.

spotlight

Setting the flash to 'on', so that it fires even when not required, makes a close-up subject stand out from the background.

FLASH OFF

Knowing when to switch off the flash is as important as understanding when to switch it on. When photographing a sunset or silhouette, the last thing you want is to illuminate anything close to camera, detracting attention from the main subject. When shooting a concert or in a theatre the stage lighting will be very bright, but the darkness of the auditorium will usually make the flash pop up. Turning the flash off makes for a better picture, exposed for the stage. For the best results, however, switch to manual mode or take a spotmeter reading from the most important area of the stage you want to expose for correctly.

spotlight

Use your pop-up flash only as a fill light, or to trigger other flash units, or, of course, to capture something close in dark surroundings.

FLASH WITH MACRO LENSES

Lighting close-up subjects, such as flowers or trinkets, can be problematic. This is because the camera's lens is so close to the subject that most natural light is blocked out. An on-camera flashgun doesn't solve the problem, as its acute angle makes it almost impossible to light the subject.

MACRO FLASH

A macro flash – where the flash tube is positioned either side of the lens – is specifically designed for close-up photography. Each can be fired to together or individually to illuminate the subject. It is usual to fire both flashes for an even light, because the closer you are the less the effect of using just one side. Some macro flash units are now designed like a ring flash, but can still be used with each side – or even the top and bottom – firing independently of the other.

To deliberately create a shadow, one of the tubes needs to be switched off. For a better, more controlled result, each tube can be set to a different output. This varies the ratio of light on either side of the subject, and is a feature common to most models of macro flash unit. This is where digital photography is so convenient, as it allows you to experiment with different settings and flash effects, and see the results instantly on the LCD screen.

Additional flashes can be used to light the background, if necessary, or to act as a rim or backlight. These additional flash units can either be triggered wirelessly, or, alternatively, fitted with slaves that will trigger the additional lights when the macro flash fires.

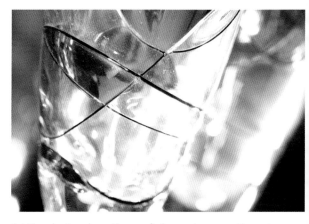

▲ When shooting glass with macro flash remember to use either a piece of white card behind the subject, or to introduce an additional flash to give it translucency.

spotlight

If you are likely only to use macro flash rarely, and don't need the ratio flash function, invest instead in a ring-flash adapter, which gives shadowless results at a fraction of the cost.

▲ A ring flash makes macro photography simplicity itself. It casts an even light, resulting in soft shadows.

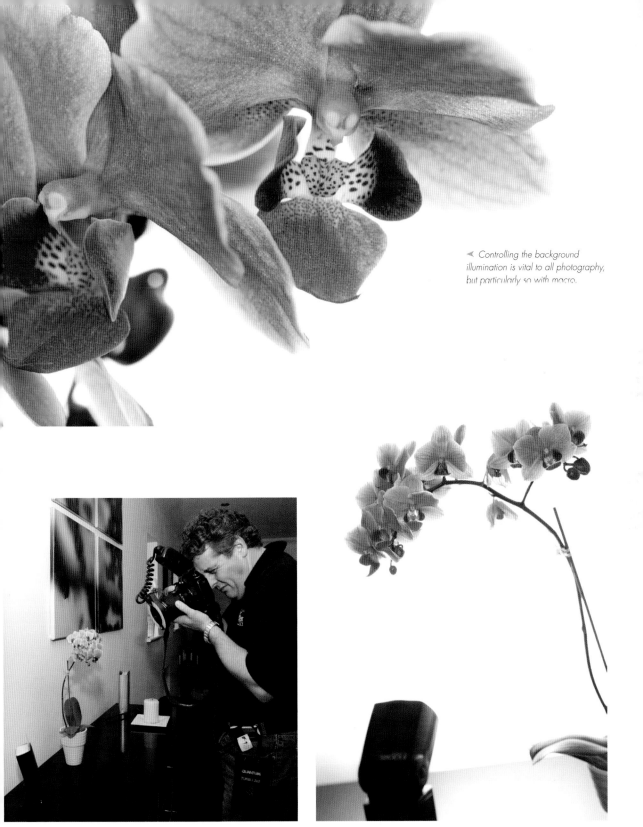

◄ Controlling the background illumination is vital to all photography, but particularly so with macro.

▲ As you can see, this orchid still life features two light sources: the macro flash – which was used to light the flower – and an additional flashgun for the background wall.

▲ I used the macro ring flash both to fire the second flash and to control its output. The background flash was set to two stops brighter than the ring flash, in order to give a perfect white background.

FLASH ACCESSORIES

A flash is not just an on-camera solution for lighting a subject. Here are just some of the ways to use your flash for greater creative effect.

ROTATION

A good flash will have the facility to swivel from left to right on-camera, or even a full 360 degrees, as well as the ability to tilt, making it possible to turn the flash in almost any direction. Most come fitted with a wideangle diffuser as standard. This is designed to spread the light more broadly when using a wideangle lens, as well as honing the focus with a longer lens. The most useful accessory for me on a standard flash, however, is the cheap piece of plastic that pulls out of the head. This is known as a bounce, or catchlight, card. When used with the flash pointing almost vertically, this little piece of plastic diffuses the harsh flash by bouncing it onto the subject.

DIFFUSERS

Other diffusers include one that resembles a large ball. This attaches to the flash to bounce and soften the light simultaneously. Some photographers make their own diffuser from an old bottle.

There are even softboxes that attach to the flashgun for softness and shape. I often use these small softboxes on my flashes, mounting them either on a stand or on a small extendable handle. This latter option allows me either to work hands-free, or my assistant to position them. This is a great benefit in small or confined spaces. These same softboxes can also be fitted both to my studio flash and my portable system.

GELS

Gels can be attached to the flash head to change the colour of the light. This technique is useful for changing a boring background or adding a splash of colour to the subject.

MULTIPLE FLASH

By linking two or more flashes together the result is a more professional-looking portrait. It is very easy to achieve. One flash (the master) tells the other flash (the slave) to fire. The on-camera flash is usually the master, while any others are slaves, firing their power when told to by the master. The master, once set up, can even control the output of more advanced flashes individually.

▲ *Several flashes can be used at one time.*

BATTERY PACKS

A flash can recycle its power quickly if fitted with fresh batteries, but this can be increased dramatically with a supplementary battery power pack, which is attached via a tethered cable. This fast recycle time is perfect for more candid portraits. When I use flash I nearly always need to recharge quickly, so external battery packs are a wise investment for me. I use the Quantum Turbo battery packs, which are available in several sizes – one of which can be used to power the flash and the camera at the same time. An external pack recharges almost instantly, so is ideal for weddings or reportage.

▲ *This softbox can be used with a normal flashgun, and also with studio and portable flash systems.*

FLASH BRACKET

A simple bracket to take the flash off-camera is useful for altering the position or direction of the flash. It's particularly handy when shooting portraits as the position of the flash can remain the same while the camera is tilted. When purchasing, make sure the bracket's height can be adjusted as this can help with unwanted shadows.

OFF-CAMERA SHOE CORD

With these bracket accessories you will need a specific cord to make full use of the flash's TTL features. These cords are quite short as they are designed to be used close to camera, but the flash doesn't have to be fitted onto a bracket – it can be held in the hand and its direction altered quickly.

▲ This cord means that the flash can be held by hand and moved around quickly in response to the subject.

SPEEDLITE TRANSMITTER

When attached to the camera's accessory shoe, this transmitter allows wireless control of the flash. The brightness and lighting ratio of multiple units can be controlled through E-TTL.

OFF-CAMERA HOTSHOE

This adapter is convenient when using a flash separately from the camera and features a tripod mount underneath. It can be connected with the camera via a connecting cord or be fired wirelessly.

UMBRELLA AND CLAMP

Some off-camera hotshoe adapters come with a bracket which can be fitted to a lighting stand. The clamps can be tilted to change the direction of the light, and also have a hole to take the likes of a photographic umbrella, thus adapting it for use as a simple studio light.

▲ The versatility of the simple flashgun is widened when used in conjunction with a range of accessories such as the Lastolite Ezybox hotshoe softbox.

RING-FLASH ADAPTER

A ring-flash adapter has many uses, and is equally suited to macro and portraiture. The adapter attaches to a flash and then uses the flash output to direct the light through a series of plastic mirrors. The result is an almost perfect ring flash, and at the fraction of a professional version of macro flash or studio ring flash.

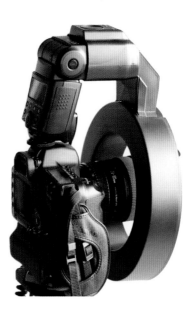

◄ The ring-flash adapter simply slips onto the flash, and can be used TTL or manual, as desired.

The more creative you want to become with flash, the more likely it is that you'll take it out of the studio. There are several ways to upgrade from a simple on-camera flash set-up, but be sure to do your research before you invest.

CONSIDERATIONS

When you step up from on-camera flash to more professional systems for location photography there are a few points to consider, the key two being portability and accessories. A professional portable flash unit has a far stronger output than on-camera flash, making it more practical in the real world, especially when bouncing or diffusing.

PORTABILITY

As my work means I travel regularly for clients, portability is my number one concern. I want to be able to get in the car or jump on a plane with minimal fuss – not to mention weight, especially as airlines surcharges are so high, and this can drastically affect the price of a shoot.

My main portable units are the Quantum Qflash 5D, which are mains independent and obtain their power from turbo battery packs. They have a range of accessories which are capable of dramatically changing the nature of the light. They are powered independently through Quantum Turbo batteries, which can also power my on-camera flash. The Qflash features a fully dedicated TTL system even when being fired remotely by a radio trigger.

▲ When travelling to clients for a shoot, portability is key – not to mention controllability. This basic, two-light set-up meant this shoot lasted ten minutes from arrival to departure. The ability to control each light makes it as simple to use as studio lighting.

CONTROL

Whichever portable flash unit you buy, make sure it has enough controllable power for a variety of tasks. Portable flash should be able to power down for still-life images and, conversely, power up for large group portraits and interiors. Auto, strobe and, most importantly, manual settings are a must for power features, as well as reliability. Swivel and bounce are almost standard, but it's best to check.

If you are looking to buy more than one unit, which is usually the case, make sure the flash units 'communicate' with each other. This will make life easy when the pressure is on during a shoot.

The dedicated TTL metering system even allows me to adjust the flash units' power settings when they are located off-camera on stands, or being held by an assistant.

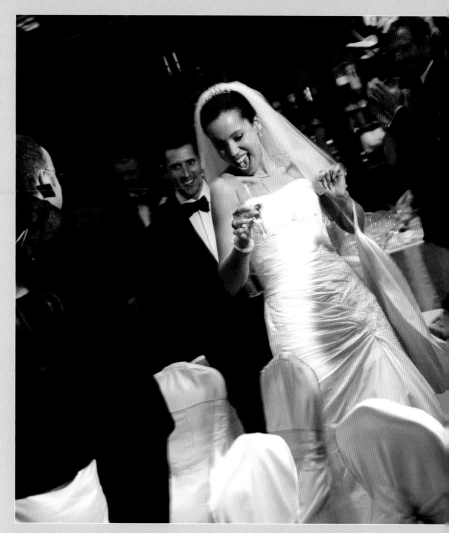

▲ When the Qflash is connected to a slave unit such as the Free X Wire, it enables my assistant to track the subjects effortlessly. Here, the Qflash is mounted on an extendable handle, so the flash fires above the bride. The newer Qflash units feature a sensor limiter, which allows you to set your distance from the subject, and forces the flash to ignore the background in order to give an accurate exposure.

◄ The units are powered by Quantum battery packs, which are available in anything from a small pocket size to a 2x2 turbo battery, which can provide enough power for two flash units or even a flash and camera power pack.

ACCESSORIES

A professional portable flash system should give you the opportunity to expand your creativity in the same way as would be expected from a studio flash.

QTTL ADAPTER

The QTTL adapter for the Qflash permits hassle-free wireless operation while making use of the TTL function of the camera. The QTTL adapter, which is mounted on the camera's hotshoe, takes control of flash output based on the TTL exposure – whether in manual mode or automatic shooting mode. The adapter will change the output at a turn of a switch to give anything from -3 to +2 stops.

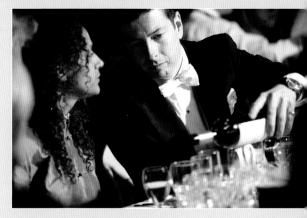

▲ *Adapter turned to +1 stop*

▲ *The standard reflector features a diffuser cap, which is useful for full flash output and, of course, to diffuse the bare bulb flash.*

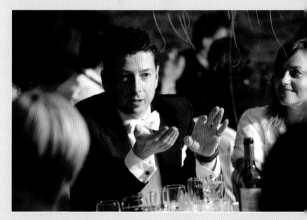

▲ *Adapter turned to correct TTL exposure (0)*

◄ *Excellent for portraits, the telereflector dish gives a wide source of light to help fill those little shadow areas.*

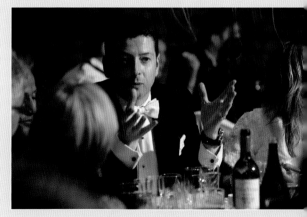

▲ *Adapter turned to -1 stop*

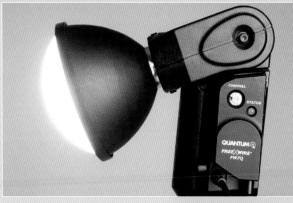

◄ ▲ A foldaway softbox for those small areas where it's impossible to put up studio lighting.

▲ ➤ Ideal for portraits and weddings, the wideangle diffuser gives a very diffused light, and allows the flash to disperse over a wider field, giving a feathered result.

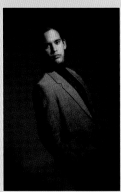

spotlight

The bare bulb enhancer is a little cone that reflects some of the light forward when using the head positioned in the bounce upright position. The scatter of light is not dissimilar to sunlight.

▲ ➤ The bracket which fits the Qflash to a lighting stand or tripod is designed to tilt in any direction.

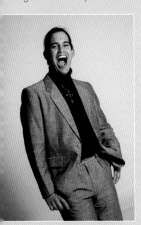

◄ ▲ The snoot is another favourite of mine as it allows for very tight control of the flash output – great for lighting and enhancing a face as well as picking out a product in a commercial shoot.

One of the key features of a good flashgun is the ability to change the direction of output. This gives a far wider scope for creativity than with a simple pop-up flash. Most good flashes come with the facility to swivel from left to right, as well as tilt, so the flash can be bounced off the ceiling or a piece of card.

BOUNCE

By bouncing flash upwards, the spread of light is increased. However, this also reduces the exposure because of the amount of light lost as a result of it being directed away from the subject. By bouncing the flash, the quality of light is softened, which eliminates the problem of harsh shadows and specular highlights.

KEY LIGHT CARD

If you are working close to the subject, you can also bounce the flash off a key light card, which is usually a piece of white plastic that pulls out from the flash head. This little card puts an attractive catchlight into the eyes as well as giving added illumination. This is because the flash is tilted upwards, so some of the flash misses the card and bounces off the ceiling, helping to illuminating the room. However, the closer you are to the subject, the less the room will be lit. For different effects try not quite fully tilting up the flash, but positioning it at a different angle instead. This pushes more of the flash towards the subject for increased exposure. However, if shooting with a wideangle lens the lower part of the image will be slightly darker than the middle and top.

SWIVEL

Using the swivel movement is essential with the key light card technique if shooting in portrait format, as the flash needs to be redirected upwards. However, the effect is not as pleasing because the card directs more of the light away from the subject compared with shooting in the landscape format. The swivel function allows the user to redirect the flash to the sides, which is perfect if you need to bounce the flash off a wall close to camera, or a reflector. I usually use a silver reflector as its reflectance means I can control the direction of the bounce accurately. Even a basic swivel function is better than flat, straight-on flash.

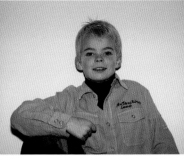

⌃ *Direct flash means the subject will be brightly lit, but any shadows created will be harsh.*

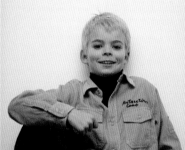

⌃ *Bouncing the flash gives a more pleasing result, but the compromise is a reduction in power.*

⌃ *Attaching the key light card to your flash adds a catchlight in your subject's eyes, and gives softer shadows.*

PROFESSIONAL HINT

When using multiple flashes remember to use the swivel and bounce features on the additional flashguns to create a range of lighting effects on the background and to backlight the subject. Flashes usually come with a little stand to make positioning of the additional flash easier.

◄ Swivelling the flash allows the user to change its direction and bounce any light off nearby walls.

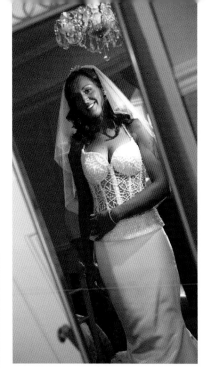

◄ When shooting a subject in a mirror, I use the camera in portrait format. The flash is in bounce light position and, with the key card, I can achieve sharply directed light, for added drama.

spotlight

When using on-camera flash as the main light source invest in an external battery pack to reduce the recharge time between shots.

▲ When using the bounce feature be careful of high ceilings or, even worse, a variety of ceiling heights. The result can be a greatly reduced exposure on the bottom of the image, as with this picture.

AUTOMATIC FLASH

There are pros and cons to using your camera and flash on automatic. For me, there are more cons than pros, as I prefer to control the image and not to rely on the camera and flash technology to make my decisions for me.

THE PROS

Setting everything to automatic does have its uses, especially when shooting from the hip. Simply pointing and shooting, allowing the flash to fully light or fill the scene, is an easy option – especially with high-end digital SLRs and their dedicated flashes.

THE CONS

When opting to shoot fully automatic be aware that the flash will usually dominate the scene, as the camera will assume the flash is illuminating the subject, and thus allow this to take priority over any natural light. However, multi-pattern metering systems on some cameras can cure this, allowing for a more realistic balance between flash and ambient light.

TV MODE AND E-TTL

Use this mode to select the shutter speed manually; the camera will automatically set the aperture based on the flash output to give a standard exposure. This is versatile as it allows you to set a slower shutter speed to control the level of ambient light in a room, or to set a faster shutter speed to freeze action.

AV MODE AND E-TTL

Use this mode to set the aperture manually; the camera will now select a suitable shutter speed for a standard exposure. This mode is useful for controlling depth of field, as the aperture will be determined either to have a shallow focus (f/2.8 to f/5.6), or a smaller aperture to increase depth of field (f/8 to f/22). This will, of course, be determined by the lens you are using and the distance from the camera to subject.

OVERRIDING

Even when shooting in automatic modes the flash can be overridden to allow more or less light to fall onto the subject, resulting in either an image that is dominated by flash, or one that simply gives some modelling to the subject.

PROFESSIONAL HINT

To get the best out of the automatic functions, follow this procedure when using a Canon camera with an E-TTL II Speedlite:

1 *Shutter button pressed halfway: autofocus and evaluative metering (with the multi-zone sensor linked to the focusing point) are executed simultaneously, and the ambient light is thereby metered.*

2 *Shutter button pressed completely: a pre-flash is fired, and the multi-zone evaluative metering sensor meters the reflected light.*

3 *The meter readings of the ambient light and pre-flash are compared and the ideal main flash output is calculated and stored in memory.*

4 *The reflex mirror goes up, the first shutter curtain starts to open, the main flash fires, the imaging sensor is exposed, the second shutter curtain closes, and the reflex mirror goes back down.*

5 *The flash exposure confirmation lamp illuminates.*

➤ *No flash – ambient exposure only.*

▲ Auto flash and manual camera – ambient exposure and auto flash.

▲ AV, TV and multi-pattern metering.

▲ Auto flash and auto camera – automatic exposure and auto flash.

spotlight

If you are experimenting with flash and its exposure dominance, try bracketing automatically. This is usually set on-camera and will give you a range of flash exposures from -2 to +2 stops.

FILL FLASH

The judicious use of fill flash can transform your pictures. As the name suggests, it fills in shadow areas, for a smoother result, and can be used to bring detail to a model's face if you are shooting into the sun.

IN USE

Fill flash is used only to lift shadow detail rather than light the subject fully. Remember, the intention is not to overpower the direction of light from the main source – be it the sun or a window. Traditionally, fill flash is set to 1½ stops less than the ambient light, which gives a 3:1 ratio in the overall image. If the shadows require more lift, then use the fill light at one or half a stop less than the main light source. This will illuminate the shadow areas without dominating. If you set the flash power at an exposure equal to the main light source, it is no longer fill light.

POWER

Fill flash is easy with today's flashes, as even if you are shooting with your camera in fully auto or manual mode, the flash can be set to reduce its output by up to three stops. In fact, in ETTL mode we only need to be able to power down by 2½ stops as three stops is equal to black. In the same way the flash can be set to increase output by up to three stops if you wish the flash to be more dominant in the image. In this way, the ambient light then becomes the fill.

BRACKETING

Some flashes have an auto bracket facility which can be custom set to increase and decrease the level of power for different fill effects each time you take a shot. As we usually take three shots per group, this might sound a great idea as you don't have to worry about getting the flash fill wrong. However, with groups, someone nearly always blinks – which is the greatest weakness of this technique, as you can guarantee that someone will have their eyes shut during the one correct exposure.

HARSH SUNLIGHT

Fill flash is mainly used in very sunny conditions, as bright sunlight always means dark, featureless shadows. A pop-up or on-camera flash is the usual solution. However, their power output is relatively low. To get around this, many photographers opt for a wider-angle lens to allow them to get closer to the subject – and thus the flash doesn't have to travel quite so far.

BACKLIGHTING

When a subject is backlit, fill flash takes on a slightly different twist, because your flash will create the main illumination of the subject if left on automatic. This is because it is designed to balance the scene. If you are shooting in manual mode on-camera, take an exposure from the face and set this as your working aperture. You then start to work out how much or little fill flash to use. The best results tend to be half to one stop less than the ambient reading.

▲ *Without fill flash.*

▲ When using the camera's TTL function but setting the exposure manually, a believable fill illumination is the result.

▲ With fill flash set to -1 stop.

▲ With fill flash set to -1 ½ stops.

When working on location there isn't always the right level or quality of light – and, of course, it's never in the right position. As a result, I, like many professional photographers, use a small portable studio flash system combined with ambient light for creative effect. I use the Quantum portable flash system, as previously mentioned, due to its portability, ease of use and range of accessories.

METER READINGS

When working on location, the first thing to decide is how bright or how dark you would like to have the background or landscape. In this sort of situation, I take an ambient meter reading to determine the level of light and to obtain an exposure. This, however, is usually only used to determine the amount of natural fill in the shadow areas of the image, or to determine the exposure for a sky.

Knowledge of shutter speeds and your camera's manual mode, combined with fully controllable flash power, are the keys to using flash successfully on location. The shutter speed is used to increase the amount of ambient fill light, the manual exposure allows for an accurate setting to be made without the camera trying to compensate from shot to shot, and a fully adjustable flash allows you to set it to fire every time with the same level of power.

▲ This set-up shot shows the Qflashes in situ. The ambient reading for this shot was f/5.6½ at 1/60sec. This is the correct exposure for the overall ambient and fill in the image. The meter was pointed back towards the camera position to record the 18 per cent grey value.

PROFESSIONAL HINT

For more dynamic images make the flash stronger in the portrait. For more subtle, realistic use of flash, angle it from the same direction as the main light source.

▲ This shows the final portrait at the same exposure as the main portrait, but with the flash switched off to demonstrate the effect the exposure change has made to the background and detail in the shadow.

▲ The subject in place, with the exposure set at f/8 at 1/125sec. As you can see, there is a dramatic difference in the image due to the increase of 1½ stops. Metering the flash power to f/8 and then altering my shutter speed to get the 3:1 ratio – just as with my studio technique – achieved this.

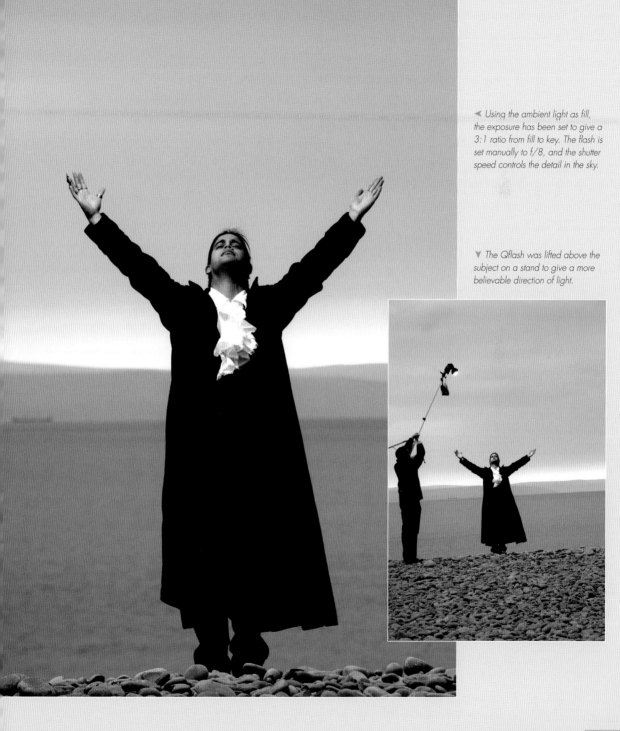

◄ Using the ambient light as fill, the exposure has been set to give a 3:1 ratio from fill to key. The flash is set manually to f/8, and the shutter speed controls the detail in the sky.

▼ The Qflash was lifted above the subject on a stand to give a more believable direction of light.

To make the image more realistic when using supplementary flash on location, try using the flash as a kicker light from behind. This gives a rim light or accent to the hair and face, especially with male portraiture.

USE RESTRAINT

Flash can often be over-used on location. This is more apparent when the camera and flash are both in automatic modes. For a more natural-looking image, control of both camera and flash exposure is essential – and this can only be achieved by relying on manual modes.

▲ *This portrait is underexposed because the light has been positioned behind the subject to give an accent to the cheek, and the side of the face and body. The flash is, in fact, accurately exposed. However, because the model is looking away from the flash the image appears underexposed, even though the detail in the highlight on the cheek is correct. This was shot at f/8 at 1/125sec.*

➤ *This second image shows the effect when the aperture on the lens is opened up by 1½ stops to give an accurate exposure from the ambient natural light. The flash now acts as a true accent on the cheek and jacket, helping give a three-dimensional roundness to the body. This was shot at f/4½ at 1/125sec.*

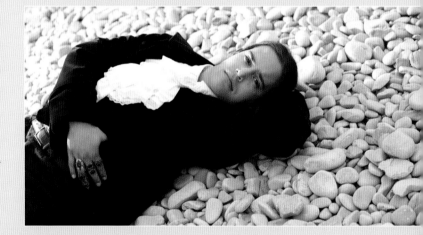

➤ *The last image shows the finished portrait using the same technique. However, the camera position has been moved away slightly as well as lowered to increase the background in the portrait. The subject has been forced to turn his head more to camera, increasing the accent on the face and jacket. This was shot at f/4½ at 1/125sec.*

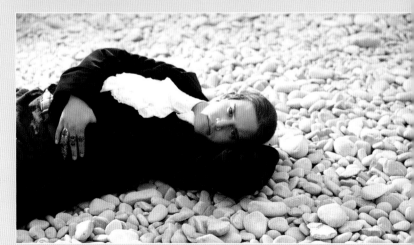

UNWANTED SHADOWS

When a subject is close to a wall or pillar be aware of any shadows that may be caused by the off-camera flash, especially when the flash output is not softened with a reflector or softbox.

At this location I was using the run of pillars to add extra interest and drama to the portrait. An ambient meter reading was taken from the expanse of light to my left. I used this reading to record the ambient light level, which was then used as the fill.

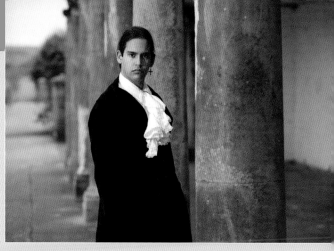

▲ Here we can see the effect of the supplementary flash, lighting the five planes of the face and giving a roundness to the body.

▼ This first image shows the placement of the Quantum flash unit – on the same side as the main source of ambient light, and positioned at a basic 45-degree angle to the subject and camera. The height of the flash is always determined by the height of the subject, just as it would be in a studio. As a rule of thumb, if the subject raises their arm at a 45-degree angle upwards, the unit would be placed at that height. This is to ensure full detail in the eyes and no dark sockets.

spotlight

When shooting with remote flash on a beach, invest in a radio trigger, which doesn't rely on another flash to trigger it.

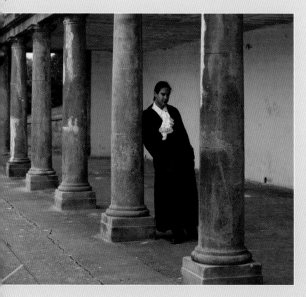

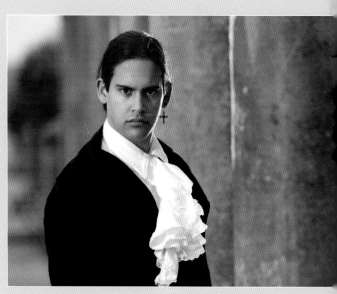

PROFESSIONAL HINT

If the subject is too close to a wall, watch out for dark shadows behind caused by the harsh flash. To avoid this problem when using pillars, simply ask the subject to step between the two columns.

▲ This time I placed a second flash unit inside the pillars to rim light the subject – even though this goes against the rule of making sure all light appears to come from just one side. However, this use of rim, or accent, light is quite common in commercial portraiture.

FRONT CURTAIN SYNC

Front curtain sync is basically the default for flash photography, and is sufficient for most photographic styles. It means that the flash fires at the start of the exposure, when the shutter first opens.

DAYLIGHT

When using flash on a normal day in conjunction with shutter speeds slower than 1/200sec, front curtain sync is employed. In this default mode, any subject movement is frozen and the full power of the flash is available.

When shooting moving subjects using long exposures, any motion blur lit by the ambient light will appear ahead of the subject in the final picture. It appears to leave the subject behind. For example, when photographing moving vehicles in this mode, the brightly coloured stripes created by headlights and taillights will appear ahead of the vehicle, rather than behind – which is what we would expect to see if the photograph is to be plausible.

△ *Second curtain sync is symbolized on the flash unit by a series of overlapping arrows.*

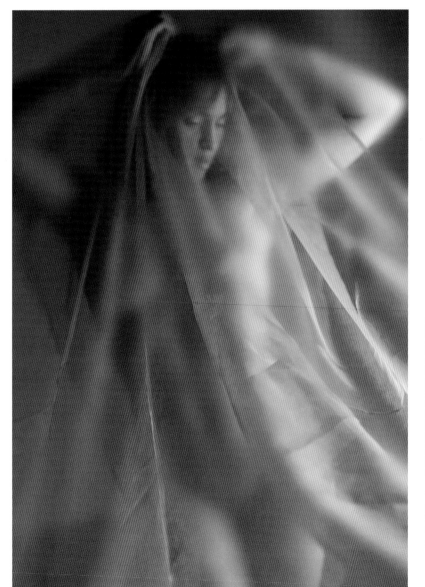

◁ *Flash is mainly used to illuminate a dark subjec or to freeze a moving one. However, if you use a slower shutter speed some movement can be recorded.*

△ *Whether shooting with an on-camera flash, portable flash or studio flash, this is the normal flash shooting mode. Any shutter speed, up to the camera's maximum flash sync shutter speed, can be used.*

REAR CURTAIN SYNC

Rear curtain sync fires the flash just before the camera's second curtain closes. The resulting blur appears different from when front curtain sync is used.

BALANCE

When your flash is set to rear curtain sync, it fires at the end of the exposure (as opposed to front curtain sync, where it fires as soon as the camera's shutter is released). This technique is used to balance ambient light with flash, and is often used in action photography. As a result, rear curtain sync – which is also known as second curtain sync – freezes the motion at the end of the exposure. When set correctly, any motion blur trails behind the moving object, rather than in front, as would be the case with front curtain sync.

spotlight

If you are shooting a model in the sea, use rear curtain sync as the waves will appear more authentic with any motion blur following, rather than leading, them.

⊼ When set to rear curtain sync, the flash fires at the end of the exposure, therefore any light trails follow the subject, rather than lead it.

⊼ When shooting with on-camera flash, any shutter speed up to the camera's maximum sync speed can be set. This is usually around 1/125sec.

SLOW SYNC FLASH

Slow sync flash is a great mode for the more creative photographer. This technique involves firing the flash with a manually selected slow shutter speed; the flash fires at the beginning of the exposure to freeze the subject, and then the exposure continues for the ambient light for the duration of the shutter speed.

APPLICATIONS

Slow sync is perfect in situations such as dramatic sunsets with a model in the foreground illuminated by flash. It is also the mode to use when you want to shoot action images of bikes or cars moving with blurred backgrounds. The flash fires to freeze the subject in its tracks, but the daylight exposure continues to record the subject as it passes through the frame, creating a streaking effect. The only disadvantage is that the flash illuminates the subject first and the camera continues to expose as the subject moves through the scene, therefore any blur records in front of the subject.

▲ Using a slow shutter speed will cause the flash to fire first, with the overall exposure continuing for the duration of the shutter speed.

▼ In this shot I metered for the building lights to gain the exposure. Then, using a long shutter speed, I asked the bride to spin around. It took several shots to get one that worked, but it was great fun. Shot at ISO 1600, 1/30sec at f/2.8.

HIGH SPEED SYNC FLASH

High speed sync flash is great for sunny days and to freeze motion. It is where flash can be synchronized with all shutter speeds on the camera. It is so useful on very sunny days because the flash acts as a fill light, avoiding the need for high shutter speeds and small apertures – even with a low ISO.

SPORTS

High speed sync can also be used to freeze subjects and minimize any motion blur. It's perfect for action sports such as skate- and snowboarding. Because higher shutter speeds can be used, the shutter speed can be set to control the exposure of the background. The result can be dramatic, and is a useful portraiture technique, especially when using wireless flash.

PROBLEMS

The only problem with the high speed sync technique is that it greatly reduces the level of flash output. This is because of the fast shutter speeds; the flash has to be recorded before the last curtain on the camera shuts, so a wider aperture is needed to compensate.

▲ 1/200sec is the highest sync speed on normal flash mode.

◄ When in high sync mode, any shutter speed can be used to control subject blur: in this case, 1/1000sec.

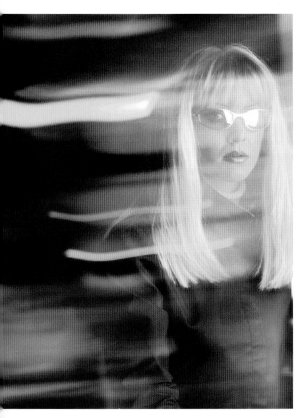

▲ Dragging the camera during the flash and long shutter speed results in these bright light trails.

PROFESSIONAL HINT

With high speed sync flash, the faster the shutter speed the shorter the effective flash range will become. Check the LCD screen on the flash for its effective flash range.

◄ Choosing a slow shutter speed with the camera on a tripod allowed me to balance the ambient light with the flash, to give detail in the background.

EXPOSURE COMPENSATION

In the same way that most cameras feature exposure compensation as a part of their custom functions, some on-camera flashes and portable flash units offer the same facility for flash.

INCREMENTS

Generally speaking, flash exposure compensation can be set to +3 or -3 stops, usually in third of a stop increments. However, if the camera's exposure compensation is in half stops, then the on-camera flash will be as well.

Flash exposure compensation is one way of using flash automatically as a fill – if set to a minus-stop compensation – or for the flash to be more dominant in a scene. It's a particularly useful technique when photographing a bride and groom walking up an aisle, as the flash will often fire automatically even though it is reading not for the happy couple, but for the nearest guest to the camera.

Flash exposure compensation is best used as a custom function so you can quickly apply set changes to it.

> **spotlight**
>
> *If exposure compensation has been set on both camera and flash, the flash will usually override the camera settings.*

⌃ *By deliberately setting the flash to overexpose by one stop, a pleasing, bleached skin effect was achieved.*

⌄ *Avoid using auto flash compensation when shooting portraits because you don't want to get the expressions right and the exposure wrong.*

FLASH EXPOSURE BRACKETING

Setting your camera to flash exposure bracketing (FEB) means it will automatically take three flash-lit photographs, bracketing as it goes.

PROS AND CONS

FEB has its good and bad points. It can make photographers lazy and too reliant on camera and flash technology. Far better to learn exactly how your flash works. However, it has its uses, especially when the subject is static – and particularly with still life, where you don't run the risk of missing the shot. It's when photographing people that FEB becomes problematic because the perfect exposure might not be the same photograph that captures the perfect expression. Once set, the flash can give a range of exposures between +3 and -3 stops. In most cases, however, it is set only to +1/3 and -1/3 stops so as not to lose the image through complete over- or under-exposure.

SINGLE SHOT MODE

When shooting in FEB mode it is best to always have the camera set to single rather than continuous shooting mode, as the flash will need time to recharge after each shot. FEB shooting can also be used with the FE lock on the camera to obtain consistent results when shooting in difficult lighting, especially with backlit subjects.

spotlight

FEB will usually be cancelled after the three shots have been taken.

▲ Flash set to -1 stop

▼ Flash set to no compensation

▼ Flash set to +1 stop

MULTIPLE FLASH

Using two or more on-camera flashes, or portable flash units, widens the scope for creativity even further. The additional lights can be varied in their strength and direction, resulting in a professional-looking image.

MORE THAN ONE

Using more than one flash will completely alter the way you see and use portable flash in an image. Just as we use studio flash to sculpt an image with light, wireless technology – which is built into many flashes – makes manual and TTL metering and exposures very simple.

MASTER AND SLAVE

With my Canon flash units, one acts as a master to control the others – which are known as slaves. The output of flash – whether master or slave – can be set individually and controlled from the master. This means you don't need to revisit each one every time you want to change their output.

If I want, I don't even need to fire the master flash on-camera, as it can be set to fire the other slave units without firing itself. This, in particular, is the beauty of wireless compared with flash units which are attached to infrared or white flash slaves. In these cases, the master has to fire to trigger the other units.

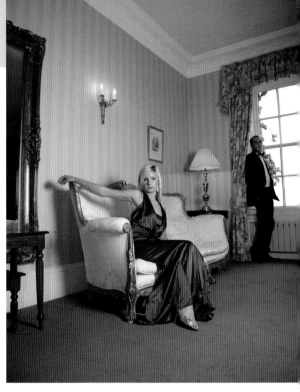

▲ When using multiple flashes and controlling them from the master slave flash on camera, each can be set to a different output. The result is more dramatic than an even, overall light, which would illuminate the whole scene.

▼ This image shows the position of the two additional flashes in addition to the one already on camera. The first is positioned to light the woman (this acts as the key light for the exposure) and the second is positioned to illuminate the man

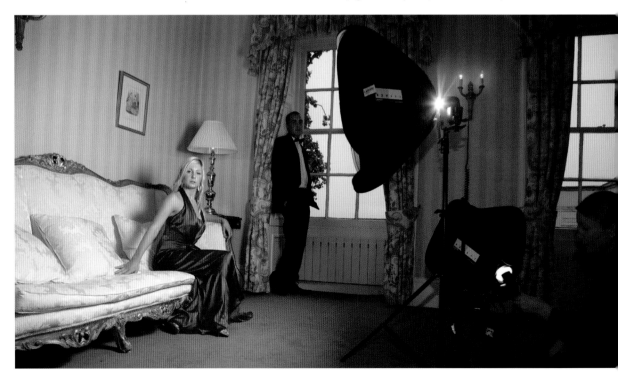

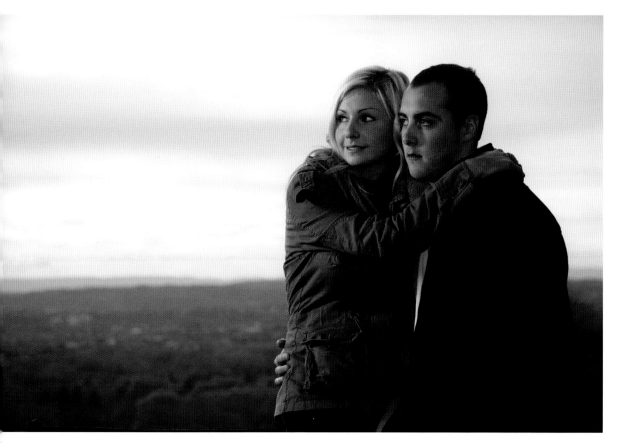

The master flash unit was set not to fire, as the drama of the image is created by the strong lighting on the subjects, combined with a maximum shutter speed to darken the sky – even though the portrait was taken early in the day.

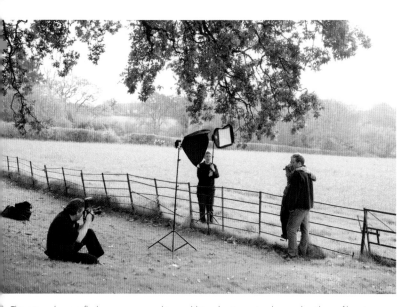

This set-up shows a flash on-camera, and two additional units on stands – each with a softbox to soften the flash. Again the supplementary lights are controlled by the master flash on-camera, using wireless triggering.

WIRELESS

My Quantum portable Qflash units work in the exact same way, using wireless technology. They, too, can be set via the camera and controlled by either a Qflash master unit, or by using the QTTL Free X Wire adapter to trigger and change power from the hotshoe.

DISTANCE

Once you start using wireless you will want your portable flash units to function further and further away from camera. The ultimate solution, as far as I am concerned, is Quantum's Free X Wire, which can remote flash from a distance of up to 500 feet (152 metres) while still supporting the auto features. This system is based on a controller on-camera and a receiver on each portable flash.

CREATING DRAMA WITH FLASH

When using portable flash on location, I always try to include some more dramatic images in the session, as they are simple to achieve with little or no additional effort needed in order to set them up. My fundamental change comes from altering the shutter speed. However, I do, on occasion, add a few coloured gels into the mix.

SHUTTER SPEED

Using the shutter speed to control the background is simple, especially with digital photography as you can really push the boundaries with no additional cost to you or the client. Using a faster shutter speed to control the background gets over the problem of having a lot of flash power on location, especially when using an on-camera flash.

Firstly, take an ambient meter reading for the sky; this should record detail in the sky. The more cloud, the more dramatic, of course. This exposure reading is now used as either the fill or as the general exposure, depending on the ambient light levels. The flash is then set either using TTL or manual. The aperture based on the sky exposure is used to set the power and work as the key light. The result is instant drama. For an even more spectacular sky, reduce the exposure further by increasing the aperture and flash output.

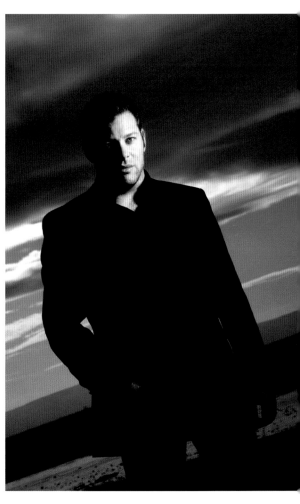

➤ *This image was shot using a Quantum flash for its increased power output to help with a bright winter's day. The Qflash is softened through a white diffusion screen to reduce its specularity. In this case I opted for portable flash rather than on-camera, as the shape of an on-camera flash is rectangular, whereas the Qflash is rounder, giving it the lightly feathered quality and softer tonal range of a studio flash.*

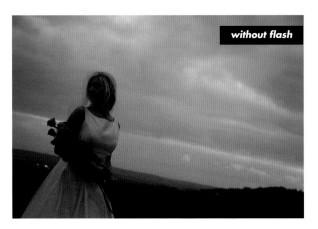

without flash

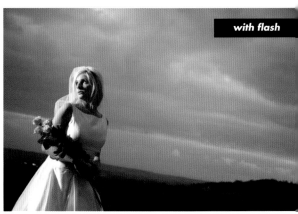

with flash

➤ *Dusk is a good time to use off-camera flash, as the sky will naturally be much darker than the subject. Here, for the image above right, flash was used to illuminate the subject, and was positioned slightly behind and to the left of the model, keeping the flash at 45 degrees to her gaze. A reflector can be used in*

situations such as these to bounce light back onto the subject. Alternatively, set the master flash on-camera to fire to do a similar job, remembering to power it down to stop over-lighting the shadow.

⅄ This series of images shows the before, the set-up and the after of a portrait shoot in a wooded environment. Firstly, an exposure was taken for he sky; the reading was 1/125sec at f/5.6 but was set on-camera to almost two stops less, at 1/200sec at f/8. This was to make the sky much darker and take any detail out of the trees.

⅄ The set-up shows the flash fitted with a softbox positioned at 45 degrees to the subject. A grey card was used to take a colour balance measure for postproduction.

⅄ Finally, a series of portraits was taken, slightly changing the composition.

⅄ ➤ A simple way to change the direction of a flash is to use it off camera, especially if you use the camera's dedicated lead, which allows all the functions of the flash to be used. With the off-camera flash lead attached to the hotshoe and the other end attached to the flash, I can use the flash off-camera up to a distance of two feet (60 centimetres). For a softer light, simply attach a softbox to your flash.

PROBLEM

A sudden cut in power, or the flash taking too long to charge – especially by the end of a flash-intensive shoot.

SOLUTION

Either purchase a never-ending supply of batteries, and change them often – especially in winter and at night, when the cold causes them to go flat more quickly – or, better still, invest in several sets of rechargeable batteries and change them several times during a shoot. Finally, you could splash out on an external portable battery pack.

▲ PROBLEM

Sync speed too high. If the shutter speed is set higher than the camera's maximum shutter speed sync with flash, the result will be a black section on the image. This is the part where the flash was not able to light the subject before the second curtain began to close.

SOLUTION

Use either a slower shutter speed, or a dedicated flash on TTL. The latter overrides the shutter speed set on-camera and chooses a more suitable speed – especially if the camera is in manual mode.

▲ PROBLEM

Too much power. If the flash is too close to a subject, even if set to TTL with manual metering on camera, it does not have enough time to switch off its output. As a result, the image will be overexposed. Too much power might also be the result of an incorrect meter reading.

SOLUTION

Take another meter reading. Check the ISO, shutter speed, aperture and, of course, flash settings.

PROBLEM

Infrared misfire. Infrared slaves are attached to additional flashes and portable flash units. They are cheaper than wireless set-ups but can be frustrating to use on location. They will fire the flash on occasion, but only intermittently, because the natural light can override the settings. As a result, the infrared slave might either not fire at all, or fire repeatedly – especially around reflective surfaces.

SOLUTION

Use a good wireless set-up on location.

▲ PROBLEM

Wireless misfire. Flashes are notorious for not firing when in wireless mode, especially if the master flash cannot see the slave units. Flashes are quite simple to set up in wireless mode, and once you have set up master and slave units several times in this way, you will have encountered most of the pitfalls of this technique, therefore wireless communication is likely to be the main problem.

SOLUTION

Invest in a more professional wireless remote system; some are almost foolproof up to a distance of 500 feet (152 metres), and can even operate around corners.

▲ PROBLEM

Not enough power. Taking an incorrect meter reading of the flash, as well as setting the wrong meter reading on camera, can result in an underexposed image. The main cause, however, for not having enough power is when the flash unit receives a reflection of its output in a mirror or glass. This can cause the flash to think it has received enough light for the desired exposure.

SOLUTION

Change camera position so you are lower or to one side.

▲ PROBLEM

Blurring. Image blur is common with slow shutter speeds – whether using flash or not. However, with flash, it records some sharpness – but with a ghostly blur around the subject. This depends on how much the subject has moved and how much ambient light is recorded.

SOLUTION

Use a tripod, a faster shutter speed, or minimize any movement on the part of the subject.

STUDIO FLASH

STUDIO FLASH

In this chapter we will be looking at studio flash – in particular, how to create simple set-ups which guarantee perfectly lit images every time. In addition, there is an introduction to manipulating the power of flash output to give better, more inspirational, portraits.

The idea of using studio flash can appear daunting at first but, once mastered, it opens up all sorts of creative photographic possibilities and, thanks to the range of accessories available nowadays, the permutations are almost endless. The key is to start simply, with just one light and, if necessary, a reflector. In addition, if you use a digital SLR the importance of being able to review your images instantly and see where you are going wrong can't be overestimated.

➤ *A deceptively simple set-up of just one softbox overhead results in this soft, glamorous portrait.*

▼ *High key lighting is one of the fundamental studio flash techniques to learn.*

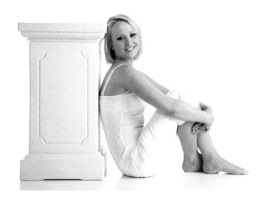

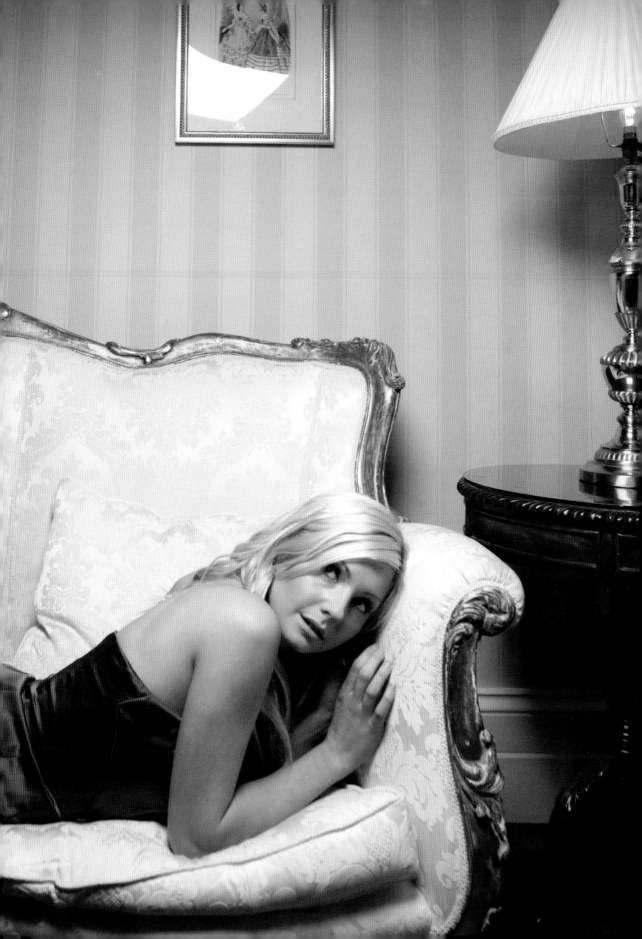

STUDIO FLASH

Using professional studio flash makes lighting a subject much easier, as there is an enormous range of accessories that are designed to soften and shape the light. In addition, studio flash has a far greater output than anything discussed so far.

MODELLING BULB

One of the key features of a studio light is the modelling bulb. This allows you to see the spread of light falling on the scene or subject – unlike on-camera flash, where you don't really know what you have until you see the results.

The power output of these units makes an on-camera flash look more like a candle. However, this in itself can be a problem if you don't learn how to control it. All studio flash now comes with multiple power output as standard, giving the photographer the ability to control the output to a fine degree.

STANDS

A studio flash is usually supported on a stand, which allows the photographer to move the light source away from the camera. This versatility means that shape and modelling of the lights is far more easily controlled – and this means more professional, higher-standard portraits or product photographs.

ACCESSORIES

Nowadays, a wide range of accessories is available which help to control flash even more precisely. These can include everything from softboxes to soften the light, to focusable spot attachments which narrow the flash into a sharp beam. Studio flash is where the next stage of being a photographer starts, and the days of on-camera flash and harsh lighting end.

▲ *Whether setting up a room as a full-time studio, or opting for a portable set-up, studio flash is compact in size and powerful in effect.*

▲ *Accessories help to shape and manipulate the light.*

➤ *Studio flash allows the creative photographer to light the subject to their best, using accessories to soften or sharpen the light for even greater effect.*

Setting up a studio incurs quite substantial expense initially but, if you keep it simple, you can achieve excellent results with basic equipment – and stay within a realistic budget. However, research before spending, to ensure you don't end up with equipment that is wrong for your needs.

LOCATION

The first decision to make is whether your studio is going to be static in premises somewhere, or portable, allowing you to move around people's homes or onto location.

PERMANENT STUDIO

If the studio is to be permanent then portable backgrounds are not a problem. The same goes for any lighting stands, props and lighting accessories. Backgrounds can be fixed to a wall or ceilings using support brackets, allowing you to have several different types that can then easily be rolled up and down using chains or, if motorized, automatically. Your studio flash can be either supported on stands or hung from the ceiling with a high glide system.

PORTABLE STUDIO

A portable studio needs to fit in a car, so bear this in mind when purchasing. Studio flash kits, most of which are very compact, collapse down quickly into carry bags, which have space for flash heads, lighting stands, leads and spare modelling bulbs, as well as simple softboxes and brollies. Backgrounds should be small enough to transport but large enough to be used for group and full-length portraits.

LIGHTING

Of the various types of studio flash, a monobloc flash head is my preferred choice as its size and portability allows me to use it in the studio or in a client's home – and even on location when attached to a special battery pack.

Monobloc flash heads have their power in the unit itself (rather than in a separate pack), and are popular for their compact size, lightness and power output.

A power pack is much heavier as its output is greater, so it is more suitable for commercial use. The pack provides the power to a separate head, the advantage of which is that it is lighter than a monobloc head.

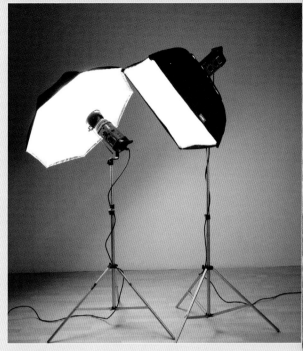

⋏ Two flash heads is generally the minimum requirement for studio lighting: one for the subject and one for the background. Good kits usually come with two or three flash heads, lighting stands, a standard umbrella, a softbox and a carry case. The umbrella is used to bounce light back into the scene for a soft spread of light, while the softbox is more directional.

⋏ In a permanent studio you should try to have as much as possible off the floor, as lighting stands and background supports can monopolize the space. Bowens Hi-Glide rails are a perfect way to increase studio space as they can support both lighting and backgrounds

MINIMUM REQUIREMENTS

A basic studio lighting set-up should consist of a minimum of two lights – one for the main light and the other for the background or fill. A four-light set-up is, inevitably, even more versatile – especially in a permanent studio set up – as each has its own job. The main light (known as a key light) is for the subject; the second is for fill, and is usually positioned behind the camera to illuminate the shadow areas; the third is for lighting the background to give separation; and the fourth can either be used as a hair light in a low key set-up, or as a second background light for high key.

STANDS

A lighting stand is essential if the flash head is to be adjustable in height and angle. Portable lighting stands are usually light and extend to around six feet (1.8 metres), but can sometimes bend a little when used with a large sofbox or heavier lighting accessory, so test them with your equipment before you purchase. Studio stands are heavier and stronger so can hold a lot more weight before bowing. Large studio stands, which can extend to some 13 feet (four metres), have an air brake system, which means that when the stand is unlocked it doesn't come crashing down when fully laden. Instead the air vacuum inside allows it to lower slowly.

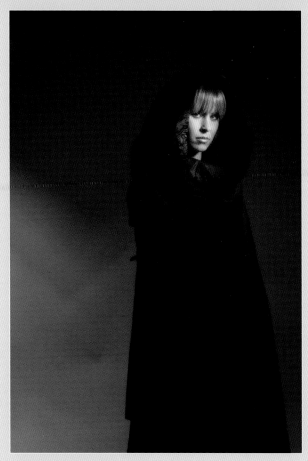

▲ Even a simple paper background such as this can contribute to an eye-catching photograph.

◄ Make sure your portable studio is truly portable. This is my lighting kit and background; all I need now is a camera bag and a car to get there.

BACKGROUNDS

My studio consists of paper backgrounds in black, white and grey; a blue, tie-dyed cloth; a PVC white background for the floor when shooting high key to save on paper costs; and a wooden floor. The simplest background is, of course, a plain white wall, so always look for one, whether in a client's home or on location. Background support systems consist of two stands, and a telescopic pole that connects the two. A paper background or curtain can either be threaded on the pole or the telescopic pole can be used to hang backgrounds from.

SOFTBOXES AND UMBRELLAS

A softbox is an essential tool for both portraits and still life, as it provides a large, even light source that gives a wide tonal range from shadow to highlight. The larger the softbox the better as far as portraiture is concerned, as it gives the photographer the option of photographing groups as well as full-length portraits. A small softbox is ideal for head and shoulders portraits and small still life or product shots, as it allows for a tighter control of the soft light source.

REFLECTORS

Reflectors are essential, as they allow you either to bounce light back onto the subject for greater impact, or to increase the quantity of light falling onto the subject – which leads to more detail in the blacks.

EXTRAS

- Two monobloc heads and power leads
- Two medium stands
- Extension cable
- One portable background
- Two reflector dishes for monobloc heads
- One soft reflector dish
- One diffusion panel

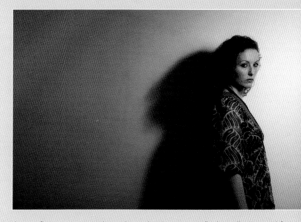

▲ A reflector on one side and a red gel over your flash is all you need for a striking image such as this.

▲ The Lastolite HiLite foldaway background is designed for high key portraits. This is more of a tent than a traditional background; the studio light or lights illuminate the background from the sides.

PROFESSIONAL HINT

Here's what you will need in order to set up a basic portable studio:
Two monobloc heads and power leads
Two medium stands
Extension cable
One large softbox
One umbrella
One background support system for paper rolls
One pop-up background
One silver/white reflector
One pack of coloured gels
One lightmeter

Gels can change the background from high key to pastel-coloured.

A boom arm is a useful accessory as it allows a light to be positioned over the subject. It has a counterweight to balance the head.

Studio stands with a cross-support are ideal for hanging a large paper backdrop when working on location, as the longest piece of kit is the background paper.

THE AMOUNT OF POWER

With studio flash, it's not a case of how much power you have, but how far you can control it – and it's certainly not always about buying the biggest and most powerful flash units. The power of flash is measured in watt seconds (w/s) or as a guide number: (M/100 ISO) equals metres at ISO 100.

MONOBLOC VS POWER PACK

Most commercial photographers prefer the power pack, which has a huge amount of power, and can be controlled precisely. A power pack allows the output of the unit to be split between anything from two to four flash heads, which means that one single 'chunk' of power can service a large set-up. However, the flash heads have to stay close to each other because they are limited by the length of the power leads running from the pack to the head.

A portrait photographer usually opts for monobloc units because of their portability and size, and, as each flash is independent, the heads can be positioned accurately and, if necessary, at a distance from each other. Monoblocs usually come in a range of outputs, from 250w/s (watts per second), to 500, 750 and 1500w/s. A unit of 500w/s is ideal for a busy portrait studio, especially if you choose one whose output can be adjusted precisely. The output of a 500w/s unit is enough to light a large group at f/11 or a small product at f/22.

TOOLS FOR THE JOB

Decide first of all what kind of photography you will be shooting the majority of the time and then select a unit that will have a little more in reserve for when you need it. If you make the right choice of output at the beginning, you should get use out of your units for a very long time. Buy too weak a unit and you will be limiting yourself.

CONTROL

Controllability is key, whether purchasing a monobloc or a power pack. The ability to reduce output is as important as its full strength. When working very close to a subject and using flash it is important to be able to dictate to the flash head how much power you want for your working aperture, and not be limited by your options because of its inability to reduce its power to the level you require.

▲ A 500w monobloc, on full power, will allow you to photograph a group with the light positioned at the same distance as the camera. This Bowens Gemini head has the ability to be turned down to 1/32 power, which allows the photographer to place the flash close to their subject, but still use a small aperture.

▲ Packs are designed to run more than one flash head and have higher output than a monobloc.

► Some studio flash systems can also be used on location in conjunction with a battery pack. This pack on my Gemini monobloc recharges the flash in 4.5 seconds.

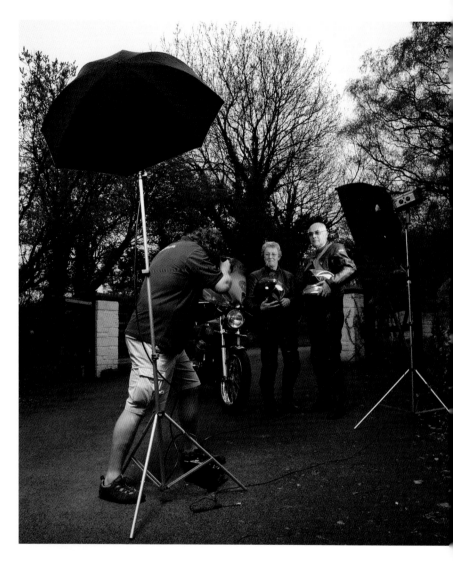

◄ The battery pack needs to be charged before use on location. I've used mine on the beach for large family groups or fashion. The battery means the lights can be used cable-free, and it can even run two heads.

There's much more to studio flash photography than soft, pleasing results. A flash head, when used in conjunction with an attachment, can be a highly creative tool which, in turn, can only benefit your photography.

CREATIVE USE OF LIGHT

Most accessories have a variety of internal finishes; this alone is designed to control the shape and spread of the light, as well as its softness or specularity. The three main finishes are polished, textured silver and neutral metallic.

POLISHED

This internal finish gives off a very harsh, mirror-like reflectance. It is superb for bouncing light off ceilings, as well as maximizing the spread of light, but the polished surface does create harder shadows and a higher contrast if directed at the subject.

TEXTURED SILVER

This features a stippled surface which diffuses the light slightly. It ensures a smooth distribution of light and is still mainly used with large reflector dishes to throw out lots of light.

NEUTRAL METALLIC

This finish is extremely popular with portrait photographers as its grey tone is very effective at softening light.

SOFT LIGHT REFLECTOR

The soft light reflector, which is a parabolic reflector by design, is my favourite accessory for portraiture and beauty photography – especially when shooting black and white. The reflector creates a harder light than a softbox, but with a feathered edge. Its double diffusion cap covers the main flash tube, then diffuses it through a large reflector dish to give a broad, soft light.

▲ *A honeycomb grid can be attached to the front of some reflector dishes in order to narrow the spread of light. This is useful for lighting specific areas of an image.*

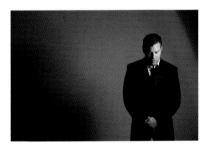

▲ *The soft light reflector throws a spread of light that is wide enough to illuminate both model and background.*

▲ *The diffuser attachment softens the soft light reflector even further. For even greater control of the light a honeycomb grid can be used instead.*

▲ *Spotlights and mini spot attachments are a great way to change a simple background into something more interesting, be it a foliage pattern, a church window or any cut-out pattern in the form of a gobo. The projection can be focused due to the spot's movable glass element.*

▲ Barn doors can be clipped on to any reflector dish to control spillage of light. This is a very useful accessory as it affords swift manipulation of the light while shooting.

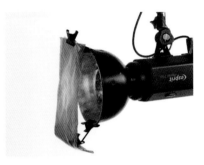

▲ It's possible to project a choice of colours onto the background or subject using heat-resistant coloured gels. These can be attached to any reflector dish using double clips, but I tend to use them in conjunction with a key light reflector, with or without the honeycomb grid.

▲ I use a snoot attachment as a simple spotlight or as an additional hair light. Because it has no diffusion its effect is more specular.

▲▼ The key light reflector dish gives a broad spread of light and, thanks to the stippled silver interior, is even and has no hot spot. It's perfect for lighting the background in a high key image.

◄ A backlight reflector is used to give a elliptical spread of light behind the subject and is commonly used in classical portraiture. The attachment has clips which can be used to hold coloured or neutral density gels in front of the light.

CLASSICAL LIGHTING

The aim of most studio lighting is to replicate, as far as possible, natural daylight – soft, directional light that gives shape and form to your subject.

45-DEGREE

The 45-degree set-up is the starting point for many portraits; mastering it will set you well on the road to becoming competent in studio lighting. Fortunately, it's easy to achieve and is based around using four lights – fill, key, hair and background. Each of these lights plays a specific role.

FILL LIGHT

The fill light should cast no distinct shadows and should not be evident in the final photograph. Set it up first, positioning it behind the camera and set to 1½ stops less than the key light (in this case f/4.5), giving a light ratio of 3:1. This is enough to hold detail in the shadows without affecting the contrast of the key light in the highlights. I use a very large softbox attached to a studio flash to diffuse the light source and provide a wash of light across the subject. However, a similar wash of light can be achieved by firing a studio flash onto a white wall behind the camera. If you do it this way, take a meter reading and adjust the light to give the same 3:1 light ratio.

KEY LIGHT

The key light shapes the subject, and should be diffused, for a soft, natural result. Fit the key light with a large softbox, keeping it as close to the subject as possible. This diffuses the light, giving you greater control over the contrast. As a rough guide, set the key light at a height where it creates a catchlight in the top of the subject's eyes. When the key light is at the correct height for both the subject and the camera position, place it at 45 degrees to the model's nose and keep it at this angle at all times. If he or she moves their head – to look away from the camera, for instance – move the key light to maintain the 45-degree position. The key light setting is metered to f/8, which is my preferred aperture for a general portrait. It gives sufficient depth of field to keep the sitter sharp from front to back, while allowing the background to go out of focus slightly.

HAIR LIGHT

The hair light's job is to separate the subject from the background, and to enhance the sheen of the hair. Position it on the same side as the key light, but far enough behind the subject so as not to be visible to the camera. The output

spotlight

Place the key light close to the subject, then move it away to observe any change in illumination, shape and pattern.

varies depending on the sitter's hair colour, as dark hair needs more illumination than light hair. As a rough guide, set it to the same as, or one stop less than, the key light. I attach a honeycomb adapter to the front of the hair light, which helps to control the direction and spread of the light to avoid any spillage on to the face.

BACKGROUND LIGHT

The background light is used to give the impression of space between the sitter and the background. Place it on a floor stand behind the subject, with a reflector dish attached to illuminate the brightest point behind the subject's shoulder blades. The light will gradually fall off to give a natural vignette, as well as drawing attention to the subject's face. The power setting depends on the colour of the background and on how much light it absorbs, but start by setting it at one stop less than the key light setting.

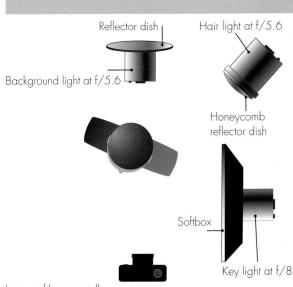

Reflector dish

Hair light at f/5.6

Background light at f/5.6

Honeycomb reflector dish

Softbox

Key light at f/8

Large softbox or wall

Fill light at f/4.5

▲ *This classic set-up gives a light that suits almost anyone, whatever their age, shape or size.*

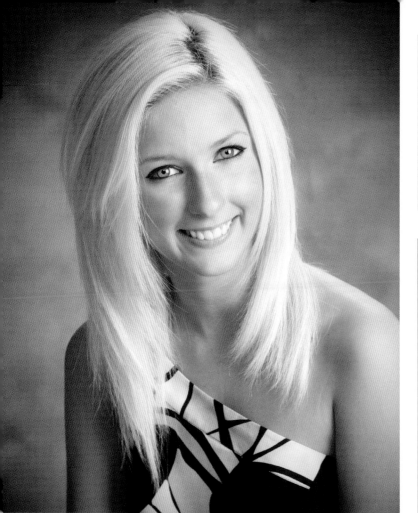

PROFESSIONAL HINT

Decide on the effects you require before you start the session. This will ensure you work quickly and efficiently, and you're more likely to achieve the variety of results you intended. If necessary, make a list.

▲ This portrait is the result of a 45-degree set-up. The image was finished with some postproduction in Photoshop, to retouch any blemishes and blend the transition from highlight to shadow.

▲ Fill light only. You can see how the light washes across the subject.

▲ Key light only. The key light's job is to make a two-dimensional print seem almost three-dimensional by injecting highlight and shadow.

▲ Background light only. This shows the spread of the background light, which finishes off the separation between subject and background.

▲ Hair light only. This shows the illumination and spread from the hair light, as well as some separation between subject and background.

NARROW AND BROAD LIGHTING

In portraiture, narrow and broad lighting is employed to give the illusion of a subject being either thinner or fuller in the face and body. At least three lights are needed for it to be effective: key, fill and either one or two background lights.

NARROW LIGHTING

Narrow lighting can make the subject appear slimmer. It is achieved via a combination of key light position, pose and head position – and refers to the side of the face least visible to the camera. The slimming effect is a result of the model's face mainly being in shadow, but it shouldn't be confused with split lighting.

BROAD LIGHTING

The broad lighting technique again relies on the combination listed above, but aims to light the side of the face most visible to the camera. Broad lighting will make the subject appear curvier because most of the face visible is lit, but shouldn't be confused with flat lighting. Broad lighting is a technique employed to convey an impression of power, and is common in male portraiture.

SPLIT LIGHTING

Split lighting, when carried out correctly, lights one half of the face, while the other falls into complete shadow. It's a very simple and effective way to alter the mood of a portrait, but is more commonly used in male portraiture.

▲ *Narrow lighting. This allows most of the face to fall into shadow, but at the same time draws attention to the five planes of the face: forehead, nose, chin and both cheeks.*

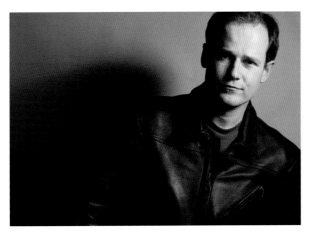

▲ *Broad lighting. Using the 45-degree lighting set-up, turn your subject slightly away from the key light so that the most visible part of the face is lit, from nose to ear. However, make sure your model doesn't turn too far otherwise their ear will dominate the portrait.*

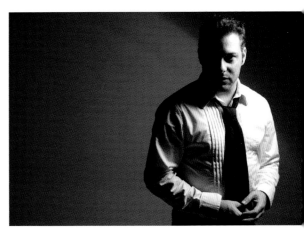

▲ *The simplest way of achieving a split lighting portrait is to minimize equipment and use only a key light and hair light. If any fill light or reflector panel was used this would add detail into the shadow area, defeating the object of the split light. The key light is positioned at 90 degrees to the subject and camera.*

▼ *Even though in this image just one light was used, the principles are the same as the classic 45-degree set-up.*

▼ *A harder-edged light source is best for split lighting as there is less feathered light to fill in shadows.*

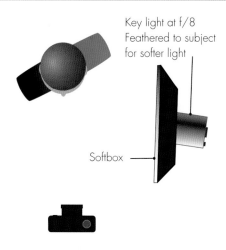

Key light at f/8
Feathered to subject
for softer light

Softbox

Soft light reflector dish on key
light at f/8, feathered for softer
light and to light background

▼ *The window principle. Use the window principle when positioning a subject in front of the light and then light placement becomes easy. The body and camera position then become the controlling factor.*

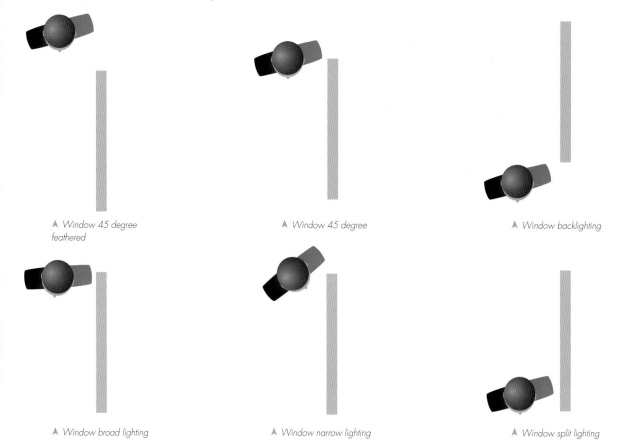

▲ *Window 45 degree feathered*

▲ *Window 45 degree*

▲ *Window backlighting*

▲ *Window broad lighting*

▲ *Window narrow lighting*

▲ *Window split lighting*

USING GELS

Coloured gels are a simple way to change the mood and impact of an image, and can be used to light either the subject or the background – or both. However, in portraiture it is always best to have some white light falling on the subject's face otherwise the result can be a little strange.

BACKGROUND

Coloured gels are commonly used to change the colour of a background. This is achieved by placing the gel in front of whichever light source is illuminating the background. The colour should complement the subject's clothing; the wrong choice can be distracting instead of harmonious.

▼ *In this image red gels have been used to add colour to both the background and the model. The model's torso and face have received additional lighting from a mini spot, whose output is one stop brighter than the scene.*

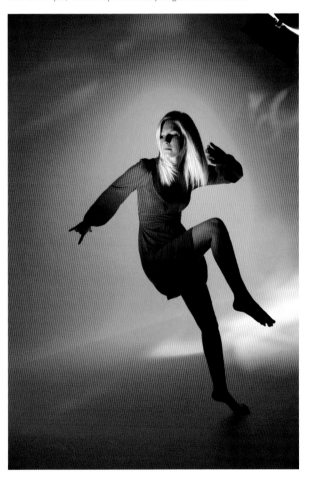

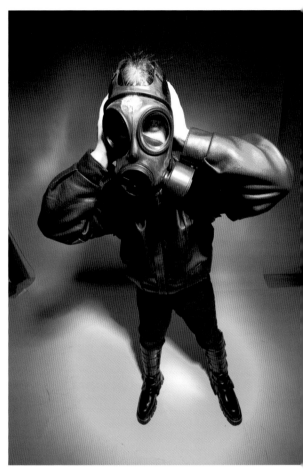

▲ *A blue gel requires more flash output as the gel reduces the amount of light falling onto the subject. For this image one light was used with a high-performance reflector attached; a blue gel was attached to the front to illuminate both subject and set.*

TESTS

When you start to use gels it is a good idea to carry out some tests, as this will give you confidence when the pressure is on during a shoot. This selection of images shows the changing intensity of colour as the power of the backlight is increased by a half stop at a time. When shooting film was more the norm, the first thing an assistant would do would be to test each coloured gel based on a classic 45-degree portrait set-up. He or she then only needed to look at the contact sheet for the each gel to know how much output to give the background in order to suit the subject's attire.

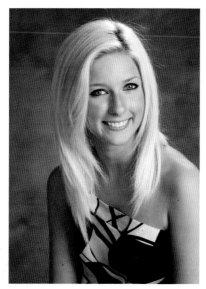

▲ *Gels are an extremely versatile accessory, and can help enhance an otherwise plain background.*

◄ *Notice how the grey background almost becomes pastel because the intense power illuminating the last image is 2 ½ stops brighter than the first. If this background had been white instead of mid tone, more high key pastel would have been the result.*

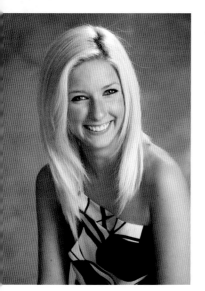

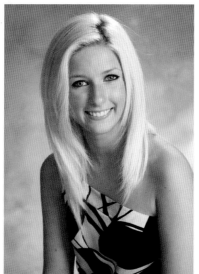

PROFESSIONAL HINT

Check the light's power setting, as different colours absorb different quantities of light:

- *Blue and red gels require the most power.*
- *Yellow requires the least power.*
- *Gels plus light background result in pastel shades.*
- *Gels plus dark background result in increased saturation.*
- *Avoid the key light spilling onto the background, which reduces the colour saturation.*
- *Combine two or three gels on one light to blend colours.*
- *Use barn doors to control the spill of the gelled light.*
- *Use white light on a model's face.*

RING FLASH

Ring flash is a popular lighting tool with fashion photographers as it gives very soft shadows on the background but, more importantly, results in a shadowless face, which is ideal for beauty work.

FASHION

The partnership between ring flash and fashion photography is a longstanding one. The characteristics include a soft shadow around the subject if they are standing against a wall, but with a tight line of shadow around the body – and not forgetting the 'O'-shaped catchlight in the eyes.

SHADOWS

A ring flash is not actually an accessory, but a stand alone flash unit. The product is quite unique as the camera is actually attached to the ring flash itself, and the photographer shoots through the middle of the flash. I use ring flash for fashion-style portraits as well as commercial fashion images. It's fantastic for beauty work because, when working close to a background, it creates an even, soft shadow around the subject – a great effect in its own right.

For more dramatic images you can combine ring flash with further studio lights. High key portraits especially take on a new twist with a more cutting-edge result.

RING-FLASH ADAPTER

A cheaper alternative to the power pack and ring flash combination is a ring-flash adapter, which simply fits to an on-camera flash. It is a great little lighting accessory and is ideal both in the studio and on location. Even though the power is nothing like a studio ring flash, it's a good starting point for many photographers, especially as it is very light in weight and price. The ring-flash adapter can be used on manual power or TTL, and recharges quickly in combination with a separate battery charger.

▲ This is the classic ringflash look. With the model standing close to the background, she is surrounded by a thin, dark line – and the overall portrait is shadowless. A close look at the model's eyes reveals the circular highlight that the ringflash is renowned for. The small amount of shadow above the subject is due to my low camera angle.

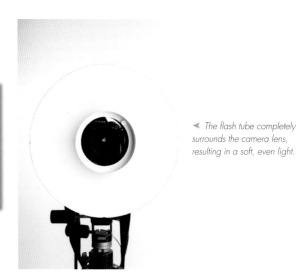

◄ The flash tube completely surrounds the camera lens, resulting in a soft, even light.

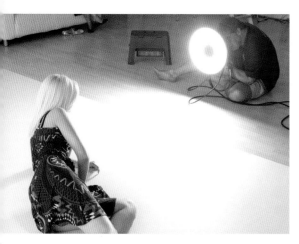

The ring flash is quite heavy to handhold. This shot shows the ringflash going off. The portrait itself has a background light set to two stops brighter than the ring flash to give a high key image.

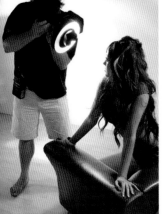

◄ A cheaper alternative to a ring flash is the ring-flash adapter.

► The closer the camera is to the subject, and the higher the camera angle, the more pronounced the reduction in exposure as the light falling on your model drops away.

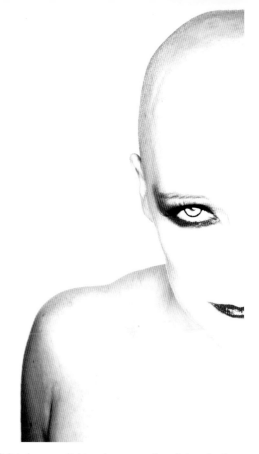

▲ The catchlight in the eyes, which is a characteristic of ring flash, makes for striking beauty portraits.

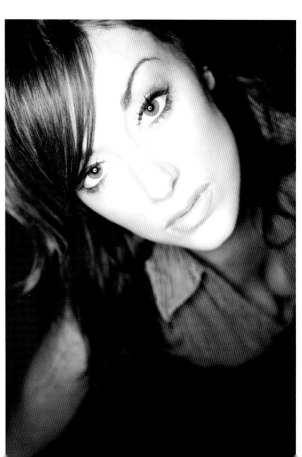

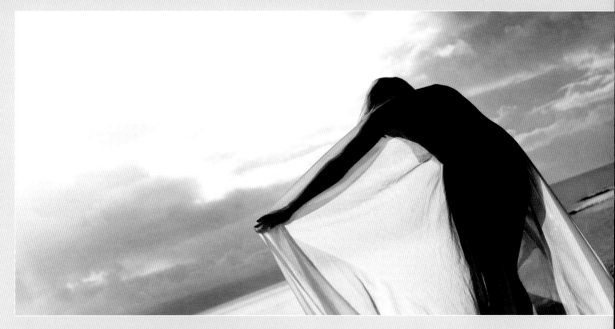

The nude has always fascinated artists, and the curves of the human body are a work of art in their own right. As a photographer, the emphasis is on creating the impression of a three-dimensional form with careful use of light.

▲ *When the sky is overcast and the light soft, I try to find a location that contrasts with the skin tone. The exposure for this scene was taken by pointing the meter towards the sky.*

SOFT OR HARD

The decision concerning whether to use hard or soft lighting for a nude series depends on the photographer's ideas and location. However, the secret is to keep things as simple as possible, and in tune with the style in mind. In the studio, avoid fill flash or overcooking the image with a reflector, as this can often be the point were an image starts to fall apart with the lighting becoming a little unreal. There are always exceptions, of course.

NATURAL LIGHT

When shooting on location I prefer natural light, using only a reflector to manipulate the light. Natural light – be it soft because of clouds, or hard because of bright sunshine – seems to enhance the pure form of the body and bring out the best characteristics of the model's skin which, incidentally, I always try to match with the location's textures. There is a little more leeway with time of day when shooting nudes. The soft warmth at the beginning and end of the day is, of course, gorgeous, but it's also possible to

get away with shooting in the middle of the day. This is because the face is not usually the most crucial aspect of my nude photographs, and top lighting falling on a nude can be very attractive.

WINDOW LIGHT

When shooting inside I always try to use the light from a window, dragging furniture closer to the window if necessary, or increasing my ISO to compensate for the light-to-subject ratio. I think of a window in the same way as a studio flash with a softbox attached, preferring to have the light falling on the subject at 45 degrees. Your camera and model have to be placed carefully in order to achieve this. Light from a window can, of course, be manipulated just like a studio flash head, using netting to soften the light or drapes and blinds to give direction.

The first decision to make is whether your studio is going to be static in premises somewhere, or portable, allowing you to move around people's homes or onto location.

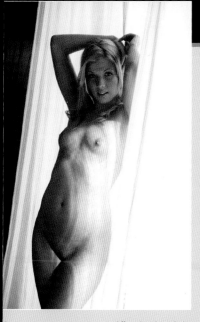

▲ Netting is an easy way to diffuse harsh sunlight coming through a window. To retain detail on the torso I took an exposure towards the sun, which ensured detail in the shadow, mid tone and even some highlight areas. The resulting image was softened in postproduction. The raw sunlight that touches the body emphasizes the subject's shape and line.

spotlight

Watch out for ugly shadows that can be cast on the body when shooting in strong sunlight or under hard studio lighting.

▼ When the sky is overcast and the light soft, I try to find a location that contrasts with the skin tone. The exposure for this scene was taken by pointing the meter towards the sky.

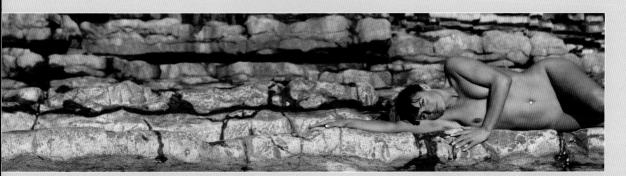

▲ When the sun is strong it can be difficult for a subject to look into the camera lens. To resolve this I ask the model to shut her eyes and open on the count of three. This minimizes any discomfort, not to mention lost shooting time caused by watering eyes.

The studio is a good place to start photographing nudes, as it's easier to control the direction of the light and gives the photographer more scope for experimentation.

FLASH

Shooting a nude with flash is more difficult than most photographers think, especially as there are no clothes to hide lighting and posing errors behind. Keep it simple: one light to do one job.

STUDIO LIGHTING

When in the studio I use studio flash for the majority of my images as the flash heads can be controlled precisely, from high output for small apertures to minimal output for more creative, selective focus, images. The quality of light given off by studio flash is also easy to modify, giving opportunities for creativity. A softbox is subtle, while the hard light from a reflector dish is great for more dynamic and graphic body lines.

PROJECTED LIGHT

Using images via a projector to illuminate the body is another one of my favourite techniques for lighting the nude. The result can be eye-catching, as long as you choose the right textures to project. Slides produce the best results, as a digital projector creates a slightly pixelated effect on the skin – although even this can be used for creative effect at times. Even though a projected image will appear very bright in a dark room compared with flash or sunlight, don't be fooled; you'll need a faster ISO or slower shutter speeds and big apertures to get usable results. However, the closer the projector to the body, the brighter the image – especially with digital projectors.

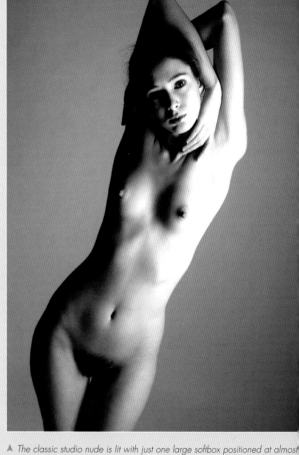

▲ The classic studio nude is lit with just one large softbox positioned at almost 90 degrees to the subject and camera. This gives a side lighting effect, and emphasizes the body's line and shape. Detail in the shadow areas can be improved, if required, either by using a fill light or introducing a reflector in front of the subject.

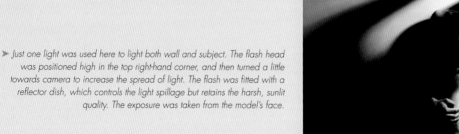

➤ Just one light was used here to light both wall and subject. The flash head was positioned high in the top right-hand corner, and then turned a little towards camera to increase the spread of light. The flash was fitted with a reflector dish, which controls the light spillage but retains the harsh, sunlit quality. The exposure was taken from the model's face.

▲ By moving the studio flash to a 45-degree position behind the subject, and asking your model to twist their torso towards it (away from the camera), strong shadow areas result. These can be controlled by the amount of body twist. With professional studio flash the modelling bulbs are so bright that it is possible to shoot at a low ISO and high shutter speeds when the light is close to the subject – as was the case here – with the addition of a silver reflector on the opposite side for graphic effect.

◀ This simple but effective nude study was achieved by projecting a slide of pebbles through a projector onto the subject's torso. The slide was placed carefully to show off the subject's piercing to best abstract effect.

HIGH KEY

High key portraiture refers to the tonal values in a portrait, and perfecting it is a must for commercial photographers. The technique is rather complex because several lights are required and therefore there is a greater chance of light spillage – which can result in flare and a lack of contrast.

TONAL VALUES

For high key the background should be lighter than the subject, which is relatively easy to achieve with small sets, and head and shoulders portraits. However, for full-length portraits of groups it is essential to light the whole background evenly, yet still to inject contrast into the subject through a classical 45-degree direction.

There are two main problems with high key portraiture: a muddy background, where it is insufficiently lit, and a halo effect, which occurs around the subject when the background is lit too intensely.

THE SET-UP

High key is a four-light set-up consisting of a fill light, a key light and two background lights. Compared with a classical 45-degree set-up the fill light can be increased in power to lift more of the shadow area: it is set to one stop below the key light setting. Again, the light is softened with a large softbox or bounced off a white wall behind camera to give a soft spread across the whole subject plane.

The key light should be softened with a large softbox to give diffused shadows. If you were to fit it with a reflector dish to give a harder light, this would throw a shadow and the 'floating' effect of the subject against the background would be lost. The working aperture of the key light is set to one stop higher in power than the fill light, and two stops less than the background lights to maintain modelling on the subject.

To achieve a clean background the background lights should be two stops brighter than the key light.

If your model is sitting on the floor, remember to lower your key light and angle it downwards. This helps keep the foreground clean in case you block the fill light with your body while shooting.

A studio flash fitted with a reflector dish and barn doors provides the ideal background light, especially for high key portraiture, where control of light is so crucial. You only need to use one barn door on each flash head, which should be closest to the subject.

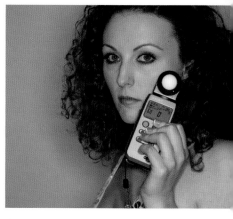

◄ If the subject is too close to the background, or if one of the background lights spills onto the subject, some detail will burn out. To avoid this problem use a piece of card – referred to as a flag – to cut out the unwanted light.

spotlight

Use a roll of white background paper for a seamless look. I use a Lastolite super white vinyl background for the flooring, which can be cleaned to save wasting paper.

▲ *Remember to switch on only one light at a time when taking the flash readings; each background light should be measured independently for the most accurate reading.*

BACKGROUND

The secret to high key portraiture lies in getting the background lighting right. Not only does the spread of light need to be controlled, but its intensity should be strong enough to create a pure white, but not so overpowering as to create flare (which will happen if the background is more than two stops brighter than the key light).

To light the background, position one flash on either side, so that the edge of each pool of light crosses in the middle. When placed correctly this will light the whole background evenly. It shouldn't look like two headlights pointing at your backdrop! These lights should be set to an output two stops higher than the key light setting. For example, if the key light is giving a reading of f/8, the background should read f/16. If your flash heads don't have enough power, reduce the output of the key light to two stops less than the background lights. For example, if you are able only to light the background at f/8, reduce your key light to give a reading of f/4. This is now the working aperture. Remember, too, to reduce the fill light to give a reading of f/2.8.

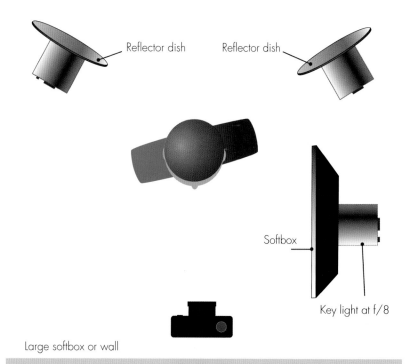

Background lights at f/16

Reflector dish Reflector dish

Softbox

Key light at f/8

Large softbox or wall

Fill light f/5.6

▲ *For more creative high key effect, swap the softbox on the key light for a reflector dish. The result will be harder and more dramatic. The harder light source will create a slight shadow on the floor, which gives the image a sense of solidity.*

ADVANCED HIGH KEY

High key lighting isn't restricted only to the softbox. A higher impact result can be achieved by reducing the quantity of light falling onto the subject. This is also a useful technique to learn for product photography, particularly if shooting transparent subjects such as glass or liquid.

LIGHT CONTROL

Try working with small light sources; the softbox can be exchanged for a reflector dish fitted with a honeycomb grid, which controls any spillage of light. Alternatively, a focusable spot attachment can be used to create dramatic lighting in pure spotlight form on the model's face, with little or no illumination falling onto the body. The same technique can be employed when photographing large groups if you have enough lights and spotlight attachments.

A third option is to switch off the fill light. This reduces the amount of shadow information in the image, creating a near-silhouette body outline, the effect of which will be graphic against the white background.

CLOSE-UP

Following on from this, a high key/low key close-up portrait can be achieved with just one light. By placing your subject close to the lit background, enough light should be reflected onto the face to create a pleasing profile; the result is striking and simple.

▲ A high key portrait can become a pastel portrait simply by clipping some acetate coloured gels to the front of the background lights. The technique also works well even when just one light is coloured by a gel.

▲ Accessories like the mini spot attachment are designed to make the photographer's job more creative.

▲ The Lastolite HiLite range of pop-up backgrounds simplifies high key photography, because it is lit from inside. They are also available with a white vinyl train.

▲ While it's possible to shoot high key with just one light, it's a bit of a headache to perfect and should be restricted to child portraiture – as in this case – where it's more easily controlled.

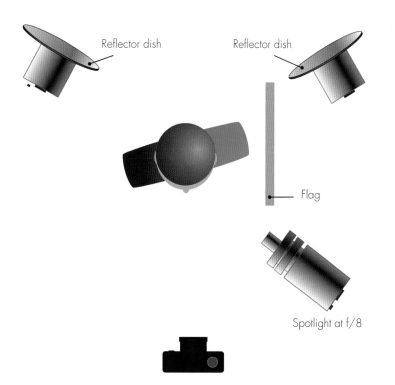

A typical high key/low key portrait. If you are working in a client's home, a piece of netting will produce a similar result to this backlit image.

ONE LIGHT

Although it is possible to create a traditional high key portrait with just one light, it should be restricted to child portraiture and, more specifically, when the subject is seated against a white background. It is far harder to get right with a full-length adult portrait. The secret is to interrupt the light falling on the subject with a large diffusion screen; this reduces the light enough for the background to read at the necessary two stops brighter. The difficult part lies in keeping the child in exactly the right place to ensure a pure white background.

The pastel shades achieved by placing coloured gels in front of the background lights give a traditional high key portrait a twist. However, care must be taken not to spill the tinted light into your subject, as this will result in an unnatural skin colour. It's easy to do – especially if you're in the middle of a shoot and hurrying – as you'll probably have opened the barn doors to insert the gel. Remember to increase the power of the background lights, or decrease the key light power and change your lens aperture, otherwise the resulting portrait will be more mid toned than high key.

➤ For more drama in a high key portrait use a spot attachment as your key light instead of a softbox.

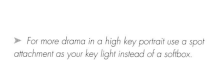

Background lights at f/16

Reflector dish

Reflector dish

Flag

Spotlight at f/8

▲ This diagram shows how to set up a high key portrait using a spotlight instead of the traditional softbox.

STUDIO FLASH AND STILL LIFE

The fine control possible with studio flash makes it the ideal light source for still-life work. The photographer no longer has to rely on the vagaries of natural light, and can create a hard or soft result at will.

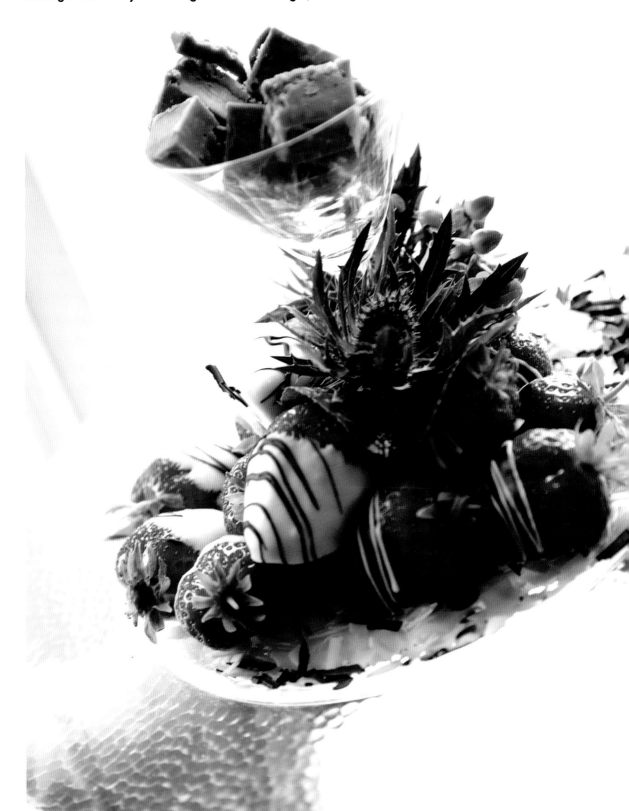

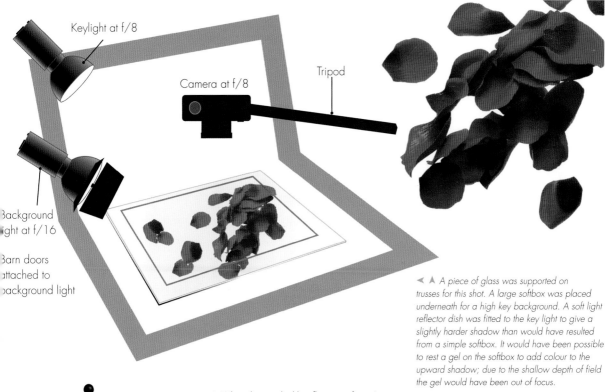

Keylight at f/8

Camera at f/8

Tripod

Background light at f/16

Barn doors attached to background light

◄ ▲ A piece of glass was supported on trusses for this shot. A large softbox was placed underneath for a high key background. A soft light reflector dish was fitted to the key light to give a slightly harder shadow than would have resulted from a simple softbox. It would have been possible to rest a gel on the softbox to add colour to the upward shadow; due to the shallow depth of field the gel would have been out of focus.

◄ When shooting highly reflective surfaces I usually set up a softbox on either side of the object, as any reflections in the object become broad and soft. Lastolite makes a light cube – basically a white tent – which I use when shooting on a client's premises. It's especially useful when shooting glass and jewellery as it can be set up with light coming from all around, if required.

◄ The benefit of studio flash is that it can simulate daylight at any time. This shot was taken at the end of a very long day shooting in the studio. The client wanted all the produce to look the same, so daylight was out of the question as the sun's direction would have changed over the course of the day – not to mention the light quality. A small room set was created using drapes and netting across the large softbox; the still life was set up on a glass table so a white piece of paper was positioned just out of shot on the floor to lift the table highlight a little. Finally, a white reflector bounced a little light back into the picture. The result? A simple shot that was nice to eat.

▲ Two lights were used for this image: one fitted with a key light reflector dish to light the drum kit, and the other fitted with a focusable spot to create the shadow. A focusable spot attachment is versatile because it can either be focused sharply for a strong result, or out of focus for something softer.

STUDIO FLASH ON LOCATION

Shooting on location with studio flash is becoming more realistic thanks to the variety of equipment available. However, unless you really need the extra power offered by studio flash, you might find you're better off with a portable flash system.

The Bowens Gemini monobloc studio flash, like some others, has the ability to be run from a portable battery. The Bowens Traveller battery pack can power two heads, so the amount of kit you need to take on location is kept to a minimum. The two main benefits with using studio packs on location are the sheer power of the flash, and the accessories that will fit onto the monobloc – such as bigger softboxes and a range of reflector dishes.

spotlight

If you are working with studio flash on location invest in some sand bags. These will weigh the studio stand down, in case of a strong breeze – especially if you are using brollies.

▼ For large group portraits, such as this family, the output from studio flash powered by a battery pack is ideal.

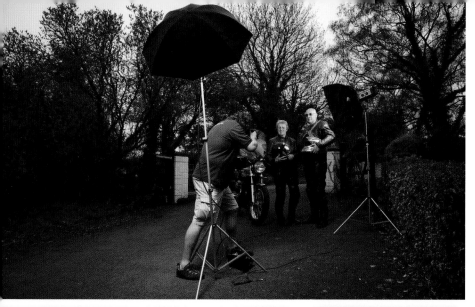

◀ The Bowens Traveller pack allows me to use my standard studio flash anywhere and at full power.

▲ With a two-light set-up – a key light with softbox and a fill light with brolly behind the camera – the Traveller battery pack recharges the flash in around three seconds. This, of course, depends on how full the battery is, and how much power is set on the monobloc heads.

▲ This image was shot with the correct exposure for the flash – but without the flash being fired. When using on-camera flash on location the shutter speed controls the ambient detail in the picture because the output is lower. However, with studio flash, the shutter speed is less significant because the aperture and flash combine for the desired effect. Shot at ISO 400, f/11 at 1/125sec.

▲ This image shows an exposure taken with the ambient light only; the image is rather washed out because of the backlighting. Shot at ISO 400, f/3.2 at 1/125sec.

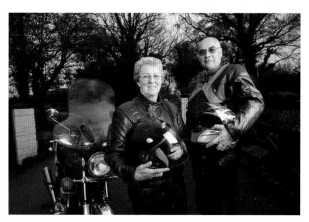

▲ In the final image the flash is switched on and fired from the camera via a radio slave. Even though I was working close enough to use a sync cable from light to camera, I prefer to remain wire-free at all times. However, the sync cord is always close at hand in case of any problems. Shot at ISO 400, f/11 at 1/125sec.

Mistakes are inevitable when you start to experiment with studio flash. However, sometimes they are the best way to learn. If you are puzzled by some of your results, the answer is likely to be found in the following examples.

▲ PROBLEM

Picture is underexposed. If the portrait is dark and muddy it can, of course, be brightened in postproduction, but severely underexposed images will give high contrast, noisy images – both in print and on screen – so an accurate exposure is preferable from the start.

SOLUTION

- Check the flash sync connection in case one of the flash heads hasn't fired. This is the most common reason, as leads can break or simply not be connected properly.
- Check the ISO on the camera and lightmeter are both the same.
- Check the aperture on the camera is set to the same as the lightmeter reading.
- Check your camera is not set to reduce the exposure automatically; this is possible with some custom settings.
- Take another meter reading in case the studio flash has not increased to the desired output.
- Check your camera's histogram if you are using the viewing screen to assess the exposure.
- Check your camera screen has not been decreased in brightness.
- Check your shutter speed is not set too high, as most have a maximum flash sync of 1/60sec. If the shutter speed is too high some cameras will not allow an external sync to fire.
- Re-calibrate your meter.
- Re-set your camera defaults.

▼ PROBLEM

Picture is overexposed. When an image is lit by studio flash and the result appears too bright it will be almost impossible to print, so an accurate exposure is essential from the start.

SOLUTION

- Check your ISO settings are the same both on the camera and on your lightmeter. This is the most common fault.
- Check the aperture on the camera is set to the same as the lightmeter reading.
- Check your camera is not set to increase the exposure automatically; this is possible with some custom settings.
- Take another meter reading in case the studio flash has not been discharged after reducing the output.
- Check your camera's histogram if you are using the viewing screen to assess the exposure.
- Check your camera screen has not been increased in brightness.
- Check your camera is not set to automatic, as this doesn't allow for external flash and can often lead to blurred and very overexposed images.
- Check your shutter speed is not set too slow. In bright locations the ambient light can be quite strong and impact on the exposure.
- Re-calibrate your meter.
- Re-set your camera defaults.

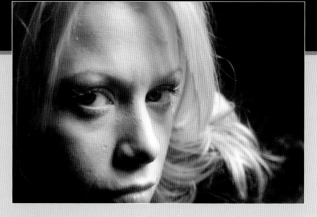

spotlight

Don't forget that blur can be used as a creative tool.

▼ PROBLEM

Black band on image. A black band on the image is caused by the shutter speed being set too high for the camera. The black section results when the camera curtain does not have enough time to fully travel across the CCD, and therefore to fully expose the whole image.

SOLUTION

Set a slower shutter speed. Consult your camera manual to find out the maximum sync speed when using external flash.

▲ PROBLEM

Photograph is very yellow/orange. An image that appears very warm is usually a result of ambient light creeping into the exposure.

SOLUTION

Use a faster shutter speed to reduce interference either from ambient light or from the modelling bulb.

spotlight

Use a radio or infrared trigger to fire the studio flash, as this will avoid cables being broken or pulled out of your camera's sync socket.

➤ PROBLEM

Blurred image. This can be caused by several things, but it usually the result of too slow a shutter speed, as even with flash the image can be blurred – either because the subject is moving too quickly for the shutter speed, or because the photographer moves their camera while the picture is exposing.

SOLUTION

■ Use a faster shutter speed to help freeze movement.
■ Set up your camera on a tripod to prevent camera shake.
■ Pan to keep the subject and camera moving in the same direction at the same speed.

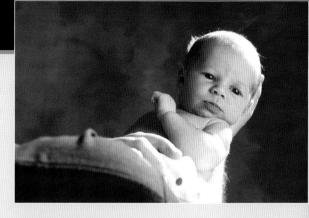

▼ PROBLEM

Bright highlights and very dark shadows. If your portrait is very high in contrast, it's probably because the lighting is too harsh.

SOLUTION

Soften the light source. Use a softbox as your starting point or hang diffusion material to soften the lighting. Alternatively, to reduce the ratio between shadow and highlight, use a more powerful fill light, as this helps increase any shadow information.

▲ PROBLEM

Burnt out highlights. Be wary of using a hair light if your subject has very fine, or very fair hair, as it will burn out.

SOLUTION

For bald heads, or heads with little hair – especially blonde – switch off your hair light completely. If you want a hair light of some sort try reducing the flash's output drastically. A hair light for this kind of subject should be set to two stops less than the key light and aperture setting. If you cannot reduce the power of the hair light causing the 'halo', you will have to increase the key light power and aperture on-camera to compensate. This is the same technique as when working outside into the sun.

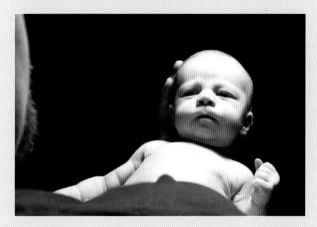

➤ PROBLEM

Reflections in glasses. A high key portrait in profile is probably one of the most difficult set-ups as the light coming from both the background and the key light is almost guaranteed create reflections in plain glasses.

SOLUTION

Try illuminating the subject with out a key light; instead light them only with the background light by positioning them close to the background. A piece of black card or material can also be positioned in front of the sitter's gaze, slightly towards the background away from the camera. However, this will help but not cure the problem. Make sure the sitter is in full profile to show some of the eye. I know some photographers who are skilled at popping the lenses out of spectacles, but I wouldn't recommend this.

▲ *A low key portrait profile is an easier solution. The portrait is far more dramatic and the reflection can be more easily controlled, thanks to the dark background.*

PROBLEM

Dark eye sockets. If you are using a harder lighting source above your subject, and their face is in shadow, it will be because the light is too far above or behind your model.

SOLUTION

To be sure of seeing a catchlight in your model's eyes, either lift their chin higher and raise your camera angle, or bring the light more towards the camera position. To add a slight catchlight in the eyes and still retain the drama of the image, set up a small spotlight pointing towards the eyes with just enough output to record the catchlight but not overpower the portrait.

PROBLEM

White background isn't clean to the edges. A white background with tone at the edges is the most common problem with high key images.

SOLUTION

Make sure the background is lit two stops brighter than the foreground subject. This will result in a pure white with no detail or flare from under- or over-lighting respectively. Place the background lights on either side of the background for an even wash of light.

PROBLEM

No background light. If the background flash does not fire, the background itself will be dark. This isn't a disaster if you're shooting on a white background as you will still achieve a little separation between subject and background. However, if you are using a black background the two will almost merge, making the portrait appear very flat, especially if you aren't using a hair light.

SOLUTION

Make sure the background slave is switched on. Switch the modelling bulb and flash on your background light to 'intermittent modelling', whereby the modelling bulb goes out to show the flash has fired, then comes back on when the flash is recharged. Shoot more slowly as your background light may be set to a more powerful output, which needs slightly longer to recharge.

PROBLEM

Lack of contrast on subjects' faces. When the main key light doesn't fire the result will be muddy and lacking in contrast.

SOLUTION

Always have your main key light as the trigger to fire the other studio lights.

MANIPULATING THE IMAGE

MANIPULATING THE IMAGE

Today Photoshop – and other image manipulation software – is as essential to the working photographer as a camera and lens. In this chapter I cover some of the skills you'll need to hone if you want to manipulate the effect of light in your photographs.

Don't be afraid to experiment. Make the most of the software at your disposal – and enjoy its capabilities. However, only exaggerate the manipulation of a photograph if it really is capable of standing up to such treatment. Otherwise, stick to the more subtle methods of improving an image so that the results are as natural as possible. Even more crucially, learn how to make the most of your RAW workflow in order to save time – which, in turn, allows you to concentrate on improving your picture-taking!

➤ *Manipulating this image turned it from something rather ordinary to something that would sell in an image library.*

▼ *Digital manipulation software opens up the world of black and white imaging.*

BASIC MANIPULATION

Don't rely on manipulation to create a great picture – always do the best you can in-camera, using digital manipulation only to enhance the subject, or to create results that would be near impossible on location.

QUICK CURE

When shooting from the hip – perhaps using just a small compact camera for general shots – you may be in a location at a time when the sun isn't in the right place, or there could be a distraction such as a crane in the background. These are all problems that can be cured easily in Photoshop.

▲ *This is typical of the kind of image I would shoot for a library. However, to get it to a commercial level I will need to carry out some simple enhancement.*

▲ *1.* Correcting colour casts is always the first stage of any manipulation process. This is carried out either through RAW, or in Levels or Curves.

▲ *2.* The next step is to bring back any detail lost by the contrast change. My preferred method is to make a duplicate layer from the original, and work on that.

◄ *3.* Retouching comes next, with the removal of any blemishes or distractions. This is carried out either with the clone tool or the healing brush.

▲ **4.** Now it's time to adjust any specific colours. Here I used Hue to increase the intensity of the picture's blue and cyan areas. In addition, I boosted the red of the building a little.

▲ **5.** If you plan to apply any effects filters to enhance the drama of the image, first save the corrected file under a different name. This becomes the first point of recall in the future, rather than the original in its raw form. The version with effects filters applied should then be saved under a different name again.

▲ **6.** Finally, crop the image – if such an action enhances the composition – and sharpen if necessary, before saving for one last time.

CALIBRATION

Calibration is an essential step in digital photography as your camera, computer monitor and printer all need to 'see' the same colours in the same way if they are to produce a print that is a replica of what is seen on screen.

COLOUR SPACE

The first thing to set on the camera is the colour space in which the image will be recorded – either sRGB or Adobe RGB. These two colour spaces have a slight variation in saturation when printed. sRGB has become the standard for the photographer who prints either via a photo lab or using their own inkjet printer as it has a wider range of colours. Adobe RGB 1998 is the colour space for the photographer who is more likely to be producing images for print in the likes of a magazine or book, as fewer colours are used in the print process.

COLOUR BALANCE

Once a colour space has been set you need to choose your colour balance, which standardizes the appearance of your images. My preference is for flash balance as it gives a warmer tone. However, this is because I shoot RAW files which are accurately colour corrected in the Adobe Camera RAW software – which is a part of Photoshop. If you are shooting JPEG then you will need to set either a custom colour balance on the camera or use the likes of an ExpoDisc to set a custom colour balance for the light in which you are working. Relying on auto white balance can cause many problems as it will try to guess the colours in a scene, which can result in variations between one image and the next.

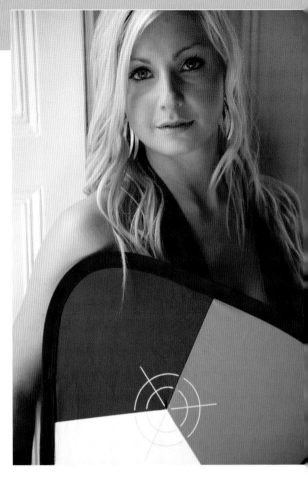

▲ A camera measures the colour at 18 per cent grey so, when colour balancing your camera, shoot a grey card or an EzyBalance reflector for accuracy. This can then be used either to set a custom balance in your camera, or to use in RAW for click balancing the corrections en masse.

MONITOR

When editing images within the likes of Photoshop, slight colour casts might be apparent, but this is not always the image itself; it is more likely to be the colour cast from an uncalibrated monitor. To calibrate your monitor you can use the free calibration tool in Photoshop, but this relies on your eyes being the judge – and they are never as accurate as a calibrator. This instrument is either dangled in front of the monitor (if it is LCD), or attached to the screen (if it is CRT). Both do the same job. The calibrator analyzes the colour levels that the monitor can show and brings them within a standard tolerance, which is neutral, and should give you far superior prints.

Calibrating your monitor only takes a few minutes; a CRT monitor should be calibrated at least every two weeks and an LCD monitor monthly.

PRINTER

If you plan to invest in a monitor calibrator, it's probably worth your while spending a little more and purchasing one that will also calibrate your printer output at the same time. The printer calibrator has a file that you print out; it then analyzes this to set a new printer profile for far more accurate prints.

spotlight

Shooting RAW files is much quicker in postproduction as the colour space on-camera is ignored as well as any colour cast being easy to correct with a simple click balance.

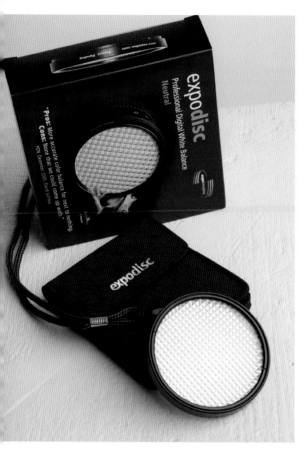

▼ An ExpoDisc fits onto the front of the camera lens to set a custom balance. This is used to average out the colour in a scene, giving a more accurate result than would be achieved with the camera's auto balance.

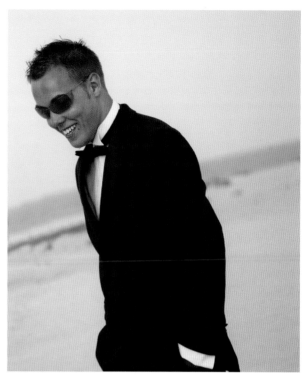

▲ While the camera's auto white balance will do a good job, one disadvantage is that it will alter the tone of the image as you zoom in and out.

▲ Once a grey card or ExpoDisc has been used to capture the colour in a scene, the camera is then told to look at that image to set the colour balance accordingly.

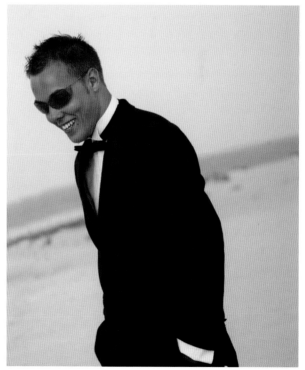

▲ I either custom balance the camera colour on location using an EzyBalance reflector, or I set the camera to flash balance and then correct all the images in postproduction.

When shooting RAW the art of colour correction is straightforward. RAW files can be adjusted time after time for different effects with no loss in the file quality.

SOFTWARE

If you shoot RAW files the images can be fine-tuned in software like Adobe Camera RAW, which is a part of

Photoshop, and far more advanced than the camera manufacturers' own software. The images can be click balanced individually or en masse for a neutral tone, or you can add a preferred colour balance. Hundreds of images can be click balanced in a second, so no need to waste time with custom colour balancing the camera on the shoot.

You can access the Camera RAW processor from Photoshop, but the quickest method is to do it via Adobe Bridge – again a part of Photoshop.

▲ **2.** *Select all the images using the top left-hand button in the window, then select the white balance tool.*

▲ **1.** *Select the RAW files you want to colour balance by clicking the first file and then shift clicking or control-clicking the files. Open them in Camera RAW (file> open in Camera RAW or CTR-R on a PC).*

▲ **3.** *Click the white balance tool on the 18 per cent grey card or, as seen here, a foldaway Lastolite EzyBalance. The image will now be neutral in tone.*

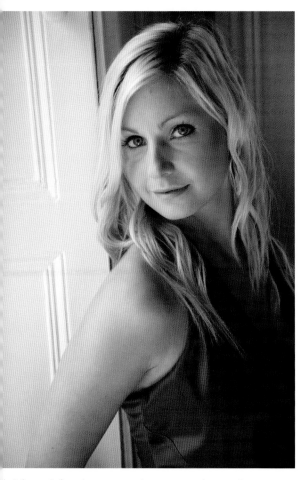

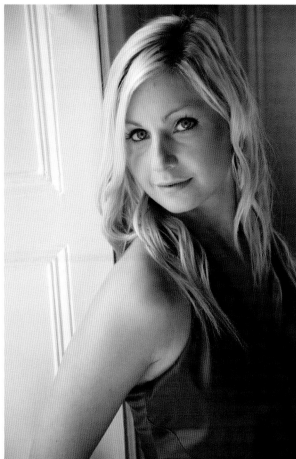

Before and after colour correction. As you can see, the original image is too warm, as a result of the tungsten lighting in the room. The corrected image (above right) features more neutral flesh tones.

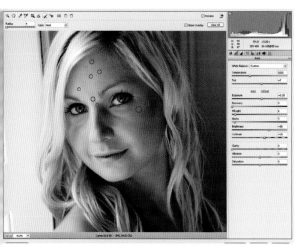

Camera RAW can also be used to fully correct the image by adjusting the exposure, as well as colour tint and even basic retouching.

I used the sliders to increase exposure and contrast slightly. Some of the minor blemishes have also been retouched.

CORRECTING EXPOSURE

Correcting any exposure errors is child's play using Bridge and Camera RAW; this leaves Photoshop for the more creative postproduction.

GLOBAL

Global exposure corrections can be applied to one or more images using Adobe Camera RAW as well as in Adobe Bridge. Once one image has been corrected, the same corrections can be applied to all – or just a selected few. When shooting RAW the image can be adjusted as much as we like without degrading the original file. However, with Photoshop CS3 these same corrections can be applied to JPEG files, affecting the image only when saved via Photoshop.

This sequence demonstrates how to recover information from an underexposed file.

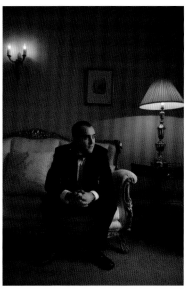

◄ *This image was slightly underexposed, so needed a bit of help to get the best out of it.*

▲ *1. The panel shows information about the image in its original form, with no adjustments applied.*

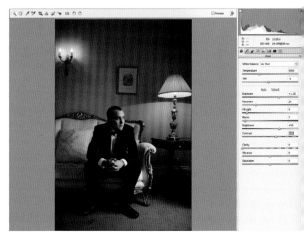

▲ *2. This panel shows the adjustments that have been applied to the image. Firstly, the exposure was increased by 1.25 stops in order to lighten the image. However, the result of this was the loss of some detail on the subject's forehead and shirt cuffs, so the recovery slider brought this back. The fill light slider was used to open up some detail in the shadow areas and, finally, the contrast was increased to balance out the overall exposure. I didn't save the image at this point, but pressed the 'Done' button to return to the Bridge window.*

◄ *3. The adjusted image was selected in the Bridge window; right clicking on the mouse brings up a new dialogue box; click on Develop Settings> Copy Settings.*

spotlight

Get the exposure right in-camera and you can miss out this step altogether!

4. The remaining underexposed images were selected; right clicking brings up the same dialogue box. This time, however, I clicked on Develop Settings> Paste Settings to reveal a new dialogue box. The new dialog box allows you to select which adjustments you would like to apply to the images; in this case I clicked 'Everything'.

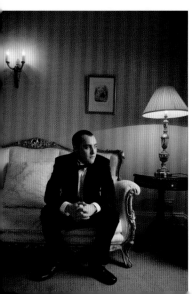

5. Bridge then applies these global exposure changes to the selected images, which is quicker than opening them up in Camera RAW, especially with a large batch of files.

◄ The corrected file, with contrast and exposure as they should be.

OVEREXPOSURE

You correct an overexposed image in the same way as you would an underexposed image, with a few exceptions. The exposure slider would need to be moved to the left (into minus figures) rather than to the right, but recovery will still be required. There's no need for a fill adjustment, but a slight increase in the blacks and decrease in contrast helps compensate for a washed out image.

▲ Even when a RAW file is adjusted in Camera RAW, the very overexposed image looks contrasty with loss of detail in the highlights.

▲ I corrected this image in Photoshop, as if from a JPEG file. As you can see, the importance of shooting RAW and using an appropriate software is vital!

LEVELS

It's a guarantee that, at some point, you will need to adjust the contrast of a photograph. Levels is by far the easiest way to carry this out.

CONTRAST AND TONE

While many photographers prefer to use Curves to achieve correct contrast and tone in a photograph, I believe the most successful and straightforward method is to use Levels. Curves can often result in blown highlights and blocked-up blacks – undesirable by anyone's standards.

You should work on the contrast only after the image has been colour corrected. Making any adjustments with either Levels or Curves degrades an image, so it is important to make the change just once, and do it right first time.

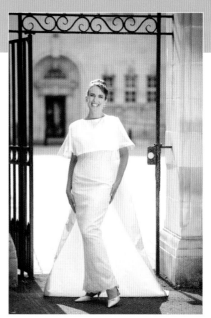

◄ The photograph, before any adjustments.

▲ **1.** First, click Image> Adjustments> Levels.

◄ **3.** To adjust the contrast simply move the black point slider (on the left) until the slider is in the middle of the first peak. Do the same for the white slider (on the right), moving it until it reaches the first peak.

▲ **2.** If you still need to correct any colour casts, select the grey picker, then click on a neutrally toned area of the image – in this case, the gates. This is slower than using Camera RAW, however.

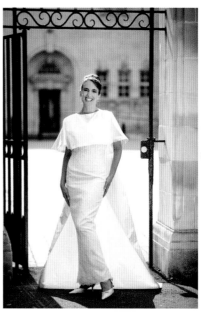

◄ The file after adjustment in Levels.

ADVANCED

f your monitor is not calibrated there is another way to carry out adjustments via Levels. In the Levels dialogue, press and hold the Alt key (or Apple key if using Mac). When you move the black and white point sliders, the image will dissolve to white; as you gradually bring the black point back you will see the gamut warning colours of clipping.

Before you move the black point slider look at the image and assess where the true shadow areas are in the image. Once you have tried this technique a few times you will begin to notice the natural deep shadow areas and will work faster as a result.

With the Alt key held down, drag the slider to the right; as you do so the image will become yellow, then red, and finally black. This is a warning which identifies the area that will block up: red and black will show no detail, while yellow will have slight information in the shadow area.

Do the same with the white point slider. This time, however, the colours will appear white and yellow in the areas where there are any completely blown highlights.

If your monitor isn't calibrated you can hold down the Alt key, which will reveal the areas that will print well, and those that will not.

spotlight

To avoid degrading an image file when using Levels or Curves, make any adjustments in a layer instead of to the image itself. This layer can be edited time after time and even dragged onto other files.

▲ Controlled clipping means the image will print with detail.

▲ This example shows that there is too much clipping in the highlight and shadow areas.

spotlight

If you need to adjust a whole folder of images with the same global corrections, make an action up in Photoshop then batch process the whole folder.

HDR BLENDING

The High Dynamic Range, known as HDR, is a tool that allows the photographer to blend two or more images that are identical except for their exposures.

DETAIL

HDR blending is all about producing an image with the maximum detail. It is especially useful for landscape photographers where it can be difficult – without the use of neutral density grads – to retain detail both in bright skies and shadow areas. If shooting with HDR blending in mind, a tripod is essential.

HDR is capable of storing 32 bits per channel, which is far higher than a 16- or 8-bit file, but after processing the image will need to be saved as an 8-bit file before printing. Blending several exposures to make one perfect exposure is simple. In this example I have duplicated the original RAW file and applied exposure corrections to the other files when blending all the images together.

spotlight

If shooting JPEG set the auto bracket function, as this will allow the camera to adjust the exposures to minimize camera movement.

▲ **1.** *Select the images to use in the HDR merge. If you have shot one RAW file then duplicate it twice and make adjustments to the two images: one for highlight detail and one for shadow. This gives a correct, an over- and an under-exposed file.*

▲ **2.** *If you are working in Bridge select Tools> Photoshop> Merge to HDR. If working in Photoshop select File> Automate> merge to HDR and then select the relevant files.*

▲ **3.** *Save the file as 32-bit to make the most of the exposure and gamma adjustments once opened.*

▲ **4.** *With the HDR image open select Image> Adjustments> Exposure to finely tune the image before reducing to 8-bit for printing.*

5. When working with a 32-bit image make use of all the exposure and gamma corrections available.

6. Finally select Image> Mode> 8 bit for the final file. It is now ready for printing.

▲ These are the original exposures, which I shot using auto bracketing. The overexposed image is needed for the shadow detail, the correct exposure is used for the general detail and mid tone, and the underexposed image is required for highlight detail.

7. Using merge to HDR within Photoshop allows you to control the detail in shadow and highlight areas.

LOCAL EXPOSURE CORRECTIONS

This is a useful technique to learn if you want to recover lost detail in highlights and shadows.

CLONING

When working in extreme lighting conditions on location, it is easy to lose detail in the shadows and highlights. A simple technique that resolves this is based on using two exposures of the same image. It can be carried out either by 'painting' the information from one image to another using the clone tool or, as in this case, by the method of dragging one image on top of the other then using the erase tool to reveal the detail in the bottom image. It's a one-minute procedure that can dramatically improve the result.

▲ **1.** This example shows the correctly exposed and underexposed files from the RAW original, both of which have been opened in Photoshop.

▲ Use a Wacom pen and tablet for finer retouching and erasing as the pen is pressure sensitive, therefore alters the opacity depending on how hard or softly you press. Turning the pen upside down instantly selects the erase tool.

▲ **2.** Using the move tool, drag the corrected exposure on top of the underexposed image. Press and hold the shift key as you move the file and the dragged image will snap to the middle.

➤ *The original exposure was metered for scene and skin tone.*

▲ **3.** *Select the erase tool then simply erase through the top image to reveal the detail in the bottom image. It is better to select a soft brush and erase about 20 per cent at a time to gradually build up the detail and make a smooth transition from one image to the other.*

▼ *A bracketed image was underexposed for detail.*

▲ **4.** *This image shows the erased section of the top image. I have switched off the bottom layer to reveal what has been erased, as well as the feathering from the brush.*

▼ *The final erased image showing correct skin tones and extra detail in the dress.*

DODGE AND BURN

Dodging and burning is a technique that many darkroom users will recognize, and it is as relevant in digital photography as it ever was. Needless to say, however, the results are quicker and more straightforward nowadays.

HIGHLIGHT AND SHADOW

The dodge and burn functions are found on the tools palette. With this image I need to dodge the highlights on the chair, the background and – most importantly – the socks, as they are the focal point of the image. The aim is to make them lighter and then burn in the shadow area on the floor and body to lose any detail. Once you know how, this is a quick task that should only take a few minutes.

▼ *The original exposure reveals too much detail in the shadow of the body, and not enough brightness in the highlight areas.*

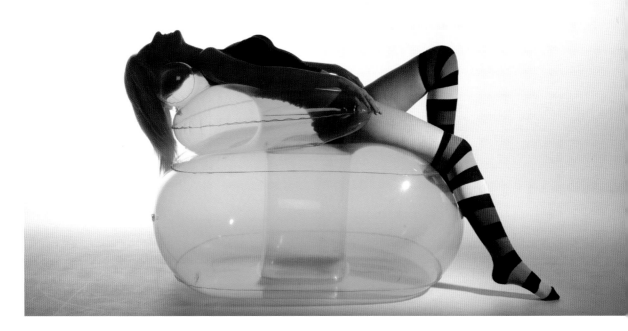

spotlight

An alternative method would be to use the eraser with 'erase to history' switched on. Remember to create duplicate layers and adjust each to a different brightness.

➤ **1.** *First select the dodge tool from the tools palette; then, from the tools bar at the top of the screen select which area you want to manipulate – the shadow, the mid tone or the highlight.*

▲ **2.** *A simple rectangle selection with the marquee tool gives a harder edge to the dodging of the background.*

▲ **3.** *As in the darkroom, you should alter the size and softness of the dodge tool in order to blend the edges successfully.*

▲ **4.** *By inverting the selection I can now swap to the burn tool and start to burn in the floor and body – where I don't need any information. Use the burn tool in the same way as the dodge tool, working in different-size brushes and opacities.*

BLACK AND WHITE FILTERS

The use of filters to enhance an image is standard procedure in postproduction. Photoshop has an array of standard filters that can dramatically change your images.

CONVERT TO MONO

To convert to mono, select Image> Adjustments> Black & White. Film photographers use coloured filters to change the tonality of an image. For example, a red filter darkens a blue sky, and therefore increases the contrast between sky and clouds; a blue filter reduces the blue in a sky and affects anything else in the composition that has a similar tone. The effect can be dramatic or subtle.

▲ This image was shot using a soft lighting set-up for increased skin tone. The key light is fitted with a softbox, set to f/8, while the fill light is set to f/5.6. Red, yellow and orange filters are always best for portraits as they whiten the skin and reduce the appearance of blemishes.

▲ Blue. Renders white skin grey and shows up spots and facial flaws.

▲ Max white. Creates a high key effect, with the emphasis on light grey tones.

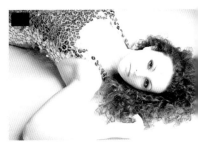

▲ Max black. The opposite of max white – bring out the darker tones.

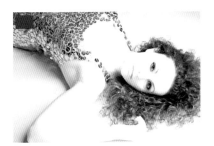

▲ Red. Whitens skin tones.

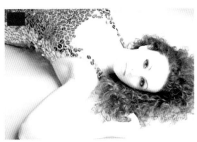

▲ Red high contrast. Washes out white skin tones.

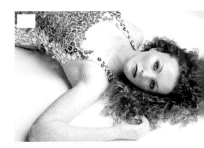

▲ Infrared. Shows up veins.

◄ This photograph was taken under the midday sun, so the light was very harsh and exaggerated the texture of the flaking paint. The exposure is very dense.

▲ Yellow. Similar result to a red filter but retains a little more tone in the highlights.

▲ Neutral density. Flattens the image to render it a mid tone.

▲ Blue. Lightens skies and the other deep tones.

▲ Blue high contrast. Lightens blues and lifts the overall tone.

▲ Green. Renders everything a mid tone – somewhere between red and blue.

▲ Max white. Lifts the image towards a more light grey.

▲ Max black. Brings out the dark tones of a picture.

▲ Red. Darkens skies.

▲ Red high contrast. Dramatically darkens blue skies.

▲ Infrared. Skies become almost black.

LENS FLARE

The beauty of using postproduction software such as Photoshop is that any image can be enhanced – or even altered dramatically – using a range of standard filters, and this includes the effect of light on a picture. It's now an everyday aspect of postproduction. The lens flare filter is particularly useful, especially when a picture has been shot into the sun, and is diffused as a result.

◄ The original image.

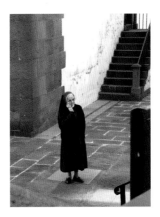

◄ After application of the lens flare filter.

▲ Filter> Render> Lens flare.

▲ The direction of flare on the image is controlled by the positioning of the cross hair in the middle of the dialogue box.

spotlight

An alternative method would be to use the eraser with 'erase to history' switched on. Remember to create duplicate layers and adjust each to a different brightness.

LIGHTING EFFECTS

The lighting effects filter can be used to create a vignette that not only gives direction to the natural light source but draws attention to the main subject.

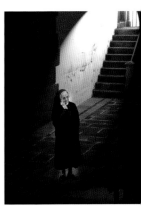

▲ The original image.

▲ The lighting effects filter adds drama to this snapshot of a nun, grabbed as she paused for a moment

▲ Position the mid point on the subject then drag the edges of the ellipse in and out until the desired effect is reached.

CHANGING HUE

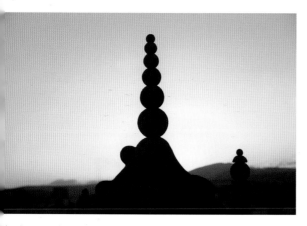

△ This original image was shot just as the sun was about to set.

△ **1.** To adjust the overall hue in Photoshop select Image> Adjustments> Hue/Saturation.

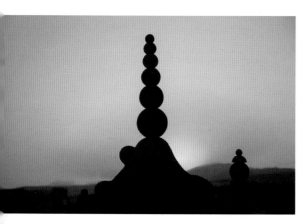

△ **2.** To give the effect of dusk, rather than dawn, a blue tone is more appropriate.

△ **3.** Use the hue slider to change the colour; notice, as hue slider moves either left or right, that the colours mix differently to form a new hue. Here I have applied a -180 change but a +180 would give exactly the same colour.

△ **4.** To increase the warmth of the image to a fiery red I went back to the original image and readjusted the hue; alternatively, I could have achieved the same result by changing the blue image.

△ **5.** I applied a -36 hue change to give a warm red. To increase the vibrancy further I applied +25 to the saturation. This can be carried out either by entering a value or moving the slider.

MONTAGE AND PANORAMA

Stitching images has never been easier, especially using the auto blend options in Photoshop CS3 or, alternatively, one of the many pieces of specialist software available that do the same job.

STITCHING

The digital work required to stitch multiple shots in order to create a panorama is becoming more straightforward all the time. It's a popular technique – and far cheaper than purchasing a specialist panoramic camera!

▲ *The three images which are to be merged.*

▲ *1. From Bridge select Tools> Photoshop> Photomerge. The files are now ready in the photomerge dialogue box in Photoshop.*

▲ *2. Select the files and click OK, remembering first to check the Blend dialogue box at the bottom of the window as well as choosing the type of alignment. I usually opt for auto.*

▲ *3. Once the image is stitched and blended, you will have a three-layer file – one for each picture used. As you can see, Photoshop has made a layer mask for each.*

▲ **5.** *Finally the image is flattened and cropped to size. I boosted the contrast in Levels and finally slightly increased saturation of the blues using hue and saturation.*

▲ **4.** *By switching off one of the layers you can see how Photoshop has stitched the images together.*

spotlight

From Photoshop access Photomerge via File> Automate Photomerge and then follow the same procedure.

BLENDING

Photoshop CS3 features advanced blending options, making it very easy to blend and retouch images. I use it all the time for changing expressions or opening eyes.

Open the two images to be blended; they must be similar to each other. Drag one image on top of the other, then double click the background layer on the layers palette and change its name.

▲ *Before and after. This is a simple, quick technique that has great results.*

◄ *Shift> click to select both layers, then align the images either via the icon on the toolbar or from Edit> Auto Align Layers. When I select the top layer and start to erase I can see the image and expressions underneath.*

LAYERS AND EXPOSURE EFFECTS

Using Layers to create a fresher, more dynamic result is one way of injecting creativity into what was originally a rather flat image. The process is explained on these pages.

In this case, I started with two exposures – one for the buildings and the other for the sky. It's important to make any adjustments before combining the images. With the sky in place, the final result is unusual and eye-catching.

original 1

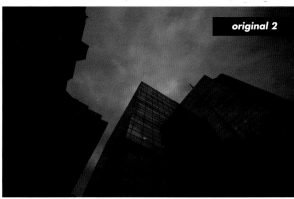

original 2

The picture above left is exposed for the buildings, while the picture above right is exposed for the sky. Combining the two creates a dynamic final image.

▲ **1.** *In Adobe Camera RAW I made some image adjustments to the RAW file before processing, mainly to increase the contrast, exposure and saturation a little; all very straightforward using the sliders.*

▲ **2.** *Before leaving Adobe Camera RAW, I have processed the image again, this time reducing the exposure drastically to give me an image with detail in the sky, as this will be my background in the final image.*

◄ **3.** *Final adjustments were made to the buildings via a Levels adjustment layer, which is accessed from the Layers palette by selecting the half moon icon and adjusting the levels in the usual way.*

spotlight

Duplicate the layers you are manipulating as a safety net in case of mistakes.

▲ **4.** *The reason for adjusting the Levels in this way is because it doesn't degrade the original image. I can work on this adjustment later at any stage without loss of quality.*

▲ **5.** *Before selecting the sky using the magic wand tool, found in the tools palette, I made a duplicate of the background layer by pressing Ctrl + J on the keyboard; this is a safety net and a habit well worth getting in to when working in a multi-layered image.*

▲ **6.** *Now I deleted the selected area (simply by hitting the delete button). By clicking the eye icon on the Layers palette, I switched off the original background layer in order to see the cut out area.*

▲ **7.** *Now I deselect the selection (Ctrl+D), and click on the bottom layer on the Layers palette; this is so that, when I drag the sky image, it will be positioned between the two layers. I then open the other image with the dark sky and drag it onto the first file I worked on. The sky image is now no longer needed.*

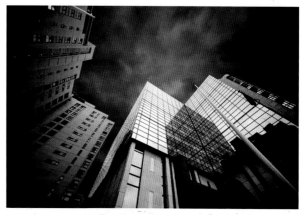

▲ **8.** *Finally, the hue of the sky is changed to red. This can either be carried out via Image> Adjust >Hue/Saturation, or by making another adjustment layer as before, but selecting Hue instead of Levels.*

▲ **9.** *The final image after a slight tweak in the levels of the sky, which finishes off the adjustments by adding a little more contrast.*

PLUG-IN FILTERS

There is a wide range of plug-in filters available for image manipulation software. These expand the default effect filters for an even wider creative scope.

FREE TRIAL

Before buying any plug-in filters for your image manipulation software, use the free trial periods to confirm whether they are likely to have much day-to-day use. I use a plug-in called Nik filters, which I discovered after much research.

Nik filters, when installed, have their own floating palette, which can be minimized or even switched off, but are always accessible from Filters> Palette.

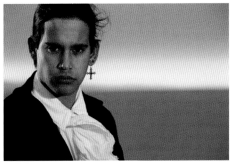

◄ The Nik filters appear in the Filter drop-down menu.

◄ Traditional Filters> Contrast> Colour Range Filter. This filter creates very high contrast images with little detail in highlights and shadows.

▲ Here the stylized filter Midnight Blue has been applied via the Nik palette. The filter is applied to the whole image via the fill bucket. Selected areas can then be removed by choosing the erase option on the Nik palette.

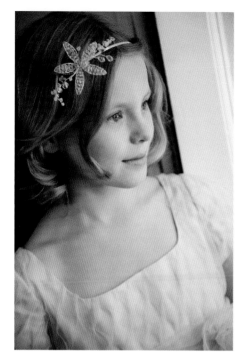

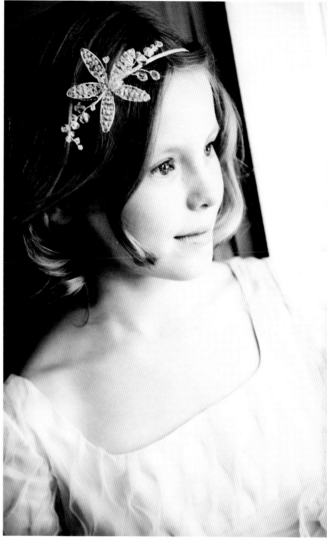

◄ ▲ *The Cool Ice Photo Styler is one of my favourites; it brings in cool blue tones, and reduces contrast. Remember the Edit> Fade option in Photoshop to soften the effect.*

▲ ➤ *The Cross Processing E6-C41 filter closely mimicks the effect of slide film being processed through C41 chemistry. This filter blows the highlights, blocks blacks and shifts the hue.*

USEFUL WEBSITES

Adobe
www.adobe.com

Bowens Lighting
www.bowens.co.uk

Calumet Photo
www.calumetphoto.co.uk

Canon Cameras
www.canon.co.uk

Lastolite
www.lastolite.com

Lexar
www.lexar.com

Loxley Colour Labs
www.loxleycolour.com

Nik Filters
www.niksoftware.com

Pro Show Producer
www.photodex.com

Quantum
www.qtm.com • www.flaghead.co.uk

Sekonic
www.sekonic.com

Wacom
www.wacom-europe.com

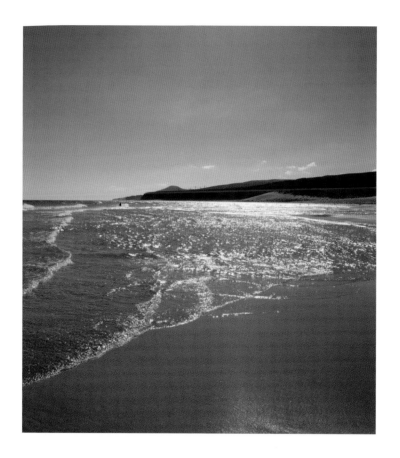

This book is dedicated to my wife, Debbie,
who is my partner in life as well as in business;
my boys, Chris and Carl, who have had to put up with
my passion for photography since they were born, and
which has taken me out of the family home too often.

And, finally, to those who have inspired me over the years as
a photographer and as a person, especially Peter Lowry,
Bob Glover and Trevor Yerbury, as well as all the assistants
I have ever worked with. They put up with my time-consuming
and – I know – very frustrating passion for light.

INDEX

Photographers' Institute Press
an imprint of The Guild of Master Craftsman Publications Ltd,
166 High Street, Lewes, East Sussex BN7 1XU
Tel: +44 (0) 1273 488005 Fax: +44 (0) 1273 402866
www.pipress.com